The Metamorphosis of Flowers

The Metamorphosis *of* Flowers

By Claude Nuridsany and Marie Pérennou

Translated from the French
by Ben Lifson

HARRY N. ABRAMS, INC., PUBLISHERS

In this world we walk on hell's roof
and gaze at flowers.

ISSA

Designer: Benoît Nacci

Project Manager, English-language edition: Ellen Rosefsky Cohen
Editor, English-language edition: Elaine M. Stainton
Designer, English-language edition: Ellen Nygaard Ford

Library of Congress Cataloging-in-Publication Data

Nuridsany, Claude.
 [Métamorphose des fleurs. English]
The metamorphosis of flowers / by Claude Nuridsany and Marie
Pérennou ; translated from the French by Ben Lifson.
 p. cm.
 IBSN 0–8109–3625–9 (clothbound)
 1. Photography of plants. 2. Macrophotography. 3. Wild
flowers—Pictorial works. I. Pérennou, Marie. II. Title.
TR724.N874 1998
779'.34—dc21 97–45862

 Harry N. Abrams, Inc.
100 Fifth Avenue
New York, N.Y. 10011
www.abramsbooks.com

Considering
Flowers

A romantic poet once wrote that paradise is an incomprehensible puzzle, its pieces spread out all around us. To find its lost splendor, we must reassemble those scattered fragments. If the poet spoke truly, the contemplation of flowers can certainly help us to recover the beauty of that lost world. And designing a garden, laying out its paths, its pools, and its shades, is both an act of creation and an attempt to rediscover our lost Eden.

I know no better reason to leap out of bed in the morning than the hope of discovering a newly opened flower in the garden. What has me hurrying down the stairs today is a clump of blazing Oriental poppies. Last night their buds had swelled to the size of quail's eggs.

I run down the path, my heart pounding; I must see what has happened. I am not disappointed, for I have caught it at just the right moment. The green sepals have opened to reveal four scarlet petals springing from the calyx, curiously rumpled, like tissue paper. They present a strange paradox; twisted like flames, glowing like coals in a brazier, they are also as still as sculpture.

Feeling marvelous, I pursue my tour of the garden. When I return a few hours later, the flower has opened out, smoothing its petals into a festooned bowl of welcome. Sure

enough, its first visitor has already come to call; a huge black bee, shimmering purple, is wallowing in the pollen-dusted stamens. The delicate bloom trembles under the visitor's weight. I wonder if I shall ever know that intoxication that a bee feels as it loses itself in the heart of a flower.

Above all, it is time, or rather, *tempo* that differentiates us from the world of plants. Our animal pulse is impatient, hurrying our lives along to the beat of seconds, whereas plants harmonize themselves to the more leisurely round of days and nights. How can we hope to see their languorous, almost imperceptible movements if we race up to them at breakneck speed?

To observe the successive changes that pass over the face of a flower as it blooms, we must visit it only now and then, spacing out our interviews. Thus, with each encounter, we discover a different season of its life.

A burst of color comes into the life of plants abruptly, like a sudden attack of fever. Up until now, the plant has methodically gone about its business, producing stems and leaves—always similar, multiplying the patterns of its growth. Then it resolutely breaks out of that orderly progression. Having fashioned only flat structures, with green as its palette's sole color, it now bursts into full roundness, building a new castle in the air. Moreover, it discovers color. After a youth of discretion, a maturity of folly. The result of this stylistic revolution is that most wonderful apparition, that mirage, that prodigy of grace called a flower.

In a way, the flower in its bud is the vegetal equivalent of the butterfly in its chrysalis. The young bloom is enclosed in the same sort of hermetic chamber as the larva, and this sealed space is the site of all its metamorphoses. Petals when newborn are

extremely vulnerable. They will, at maturity, spread across great surfaces, colored panels whose mission is to attract pollinating insects. Inside the bud, however, they are often wound in spiral form, the preordained figure that allows them to take up the least room. Tightly interlocked, they are more resistant to both shock and dehydration.

Plants are economical creatures. Their metabolism goes in slow motion. But when it comes time to bloom, extravagant needs countermand their accustomed thrift: to fabricate in a few weeks those fleeting and beautiful constructions called flowers commits vegetables to enormous expenditures of energy. For many, this lovely moment is a swan song. Annuals and biennials purchase their single blossoming with their lives.

With the agave, or century plant, native to Mexico and common to the south of France, the case is even more dramatic. For about fifteen years this robust plant develops a vast rosette of serrated leaves gorged with water, like wineskins. Then this prudent creation, after years of daily triumphs over dryness, throws caution to the wind. For about a month it brandishes a ten-meter-high spike at the sky, a hastily built edifice that exhausts its body completely. The plant never survives its one architectural extravaganza.

For botanists bamboos are a true enigma. After thirty, sixty, eighty, or even a hundred years they blossom for the first time in their lives, and then die. This phenomenon has about it something suggestive of collective suicide on the planetary scale: all bamboos of the same species, no matter where they grow, produce their flowers in the same year.

In parts of Asia, this global wave of flowering and death has a disastrous effect. Not only does the principal building material become momentarily unavailable as

everyone awaits the germination of new bamboos, but the explosive dissemination of bamboo seeds brings on swarms of rodents that do not stop at eating bamboos, but go on to attack the food crops. In the annals of Asian history written records of this recurring drama can be found over a period of two thousand years.

We don't know what sets off the bamboo's epidemic blossoming, although some fanciful minds readily invoke the highly improbable action of sunspots; nevertheless botanists have advanced our knowledge of flowers' capricious physiologies. What is it, then, that leads a plant to abandon itself to floral madness?

In some climates it is the lengthening of days, but in the temperate latitudes it is, paradoxically, the cold that triggers the appearance of flowers. Thus the lilac produces buds as early as August, but it holds them in a state of suspended animation through the winter. Cold weather breaks through the plant's reserve, so that, with the onset of good weather, the buds will burst explosively into clusters of flowers.

Armed with this knowledge, florists do not shrink from forcing nature by subjecting the foot of the lilac bush, as early as September, to almost freezing cold. Transplanted to hothouses, lilacs are then quick to bloom. Strangely enough, the same results are obtained by using anesthetics like ether and chloroform, and horticulturists make free with them, for the sale of out-of-season flowers is a profitable business.

For a plant, to bloom is to emerge from anonymity, to throw off its mask and finally show its true face. A flower is a signature, an ensign, a blazon. To identify a plant without seeing it in bloom is as delicate a matter as to recognize a person whose face one

can't make out. A flower is a plant's face, its most singular feature, the expression of its personality, the symbol of its identity.

In the eighteenth century the great Swedish botanist Carl von Linne (1707–1778), whom we call Linnaeus, proposed a new system of plant classification based exclusively on flower structure. This principle of identification proved so fruitful that little by little it gained ground in the scientific world and is still in effect today.

A flower seems to concentrate so much of a plant's inventive capabilities that one can lose oneself for a long time in speculation about the nature of blooming. Indeed it was a poet who first understood the origin of the flower. In his *Metamorphosis of Plants* Goethe proposed a unified vision of plant morphology. Rejecting the reductionist method typical of science in his day—whose aim was to understand the whole by studying the part—Goethe approached the problem in a novel way, favoring a holistic understanding of the plant.

A blossom appears as though an anomaly, an eccentricity in the common sense organization of plants. Goethe sought a simple general principle to explain the flower's enigmatic origins. The key to the solution, he found, was in the leaf. "Although apparently dissimilar, the organs of a plant in the process of developing either its leaves or its blossoms stem from the same component, namely the leaf. . . . Thus [with the blossom] nature does not form a new organ but merely recombines and modifies organs already known." A flower, in other words, is a delicate assemblage of modified leaves concentrated at the top of the stem.

Behind its apparent fragility, a blossom conceals an architectural conception worthy of a fortress: a collection of concentric enclosures (similar to nesting boxes, or

Russian dolls) with a sanctuary at its center. The outermost wall, made up of sepals, forms the calyx. Within this rampart is a second one, the corolla, composed of an assemblage of petals. Then comes one or many rows of stamens, the flower's male organs. Beyond these is the pistil, hidden at the flower's center, a column whose thick base contains the ovules that, once germinated, develop into seeds.

What a plant clothes with such elaborate care, then, is its potential offspring. Botanists call flowering plants angiosperms (that is, "enveloped seed"), in contrast to gymnosperms ("naked seeds"), chiefly represented by pine trees and other conifers.

By wrapping its generative organs in a calyx and a corolla the flowering plant protects them against rain, cold, and the attacks of fungus, infection, and foraging animals. The evolution of this floral cradle was plainly a happy innovation, for today we can number almost three hundred thousand species of flowering plants as opposed to six hundred species of conifers.

By playing with these parts—sepals, petals, stamens, pistil—as basic elements, flowers have developed innumerable combinations, like variations on a musical theme.

Throughout the ages plants have been thought of as almost angelic creations. Far removed from the follies of animals and human beings, from dramas and passions, they symbolized the last refuge of chastity. Their placid, serene, and seemingly timeless existence gave no hint of sexuality.

In his *Metamorphoses*, the Latin poet Ovid recounted a variety of episodes of miraculous transformation, a theme that pervades Greek and Roman legend. A recurrent story tells of a mortal who wishes to escape the amorous advances of a god, and is consequently transformed into a tree or a flower. Apparently, the desires of the gods them-

selves were impotent before the impassive and sovereign virginity of plants, at least in the primeval thinking of the Early Greek world.

In ancient Rome, however, the April celebration of the Floralia, the festival of Flora, the goddess of spring, was anything but chaste. Courtesans took part, and the revelry often took an orgiastic turn worthy of the bacchanal. And even though flowers were thought of as chaste, their flowering gave the signal for the opening of the season of love.

At the end of the seventeenth century Rudolph Jakob Camerarius, professor of medicine at Tubingen, Germany, published his *Letter on the Sex of Plants*. For the first time a scientist addressed the idea of plant sexuality. But his thesis had a twofold handicap: it was both revolutionary and indecent, and so it ran up against a wall of savage skepticism.

When, a half-century later, Linnaeus proposed his system of plant classification based on a painstaking examination of flowers' sexual organs, many botanists approved of the new mode of classification, but it led moralists to deplore young ladies' traditional interest in flowers—now that the world of plants had lost its innocence.

But it was in 1793, in Germany, that the most startling work on the sexuality of flowers appeared, illustrated with twenty-five magnificent copper-engraved plates based on the author's own observations. The title has the solemnity of a manifesto: *The Mystery of Nature Unveiled in the Structure and Fructification of Flowers.* Christian Konrad Sprengel (1750–1816), the highly respected rector of a college in Spandau, near Berlin, brought to his minutely detailed study of flowers in their natural settings such a high degree of devotion that he was relieved of his post for neglecting his religious duties.

Sprengel's book discussed the subtle and highly organized interactions of flowers and insects, and it established, before the coining of the term, an "ecology" of pollination. But his observations were far too advanced for his time. His work was not accepted by the scientists of his own day, and he died in poverty, surrounded by incomprehension and contempt. Worse, he was thought to be something of a fanatic.

It was the great Charles Darwin, the father of the theory of evolution, who, in the last century, rescued Sprengel's work from oblivion. Darwin confirmed the greater part of Sprengel's observations, which he, Darwin, then went on to make the most of in his theory outlining the process of natural selection. But in the Victorian era, reproductive biology, even that of plants, was considered an unseemly topic. It was not until the twentieth century that plant reproduction was taught in the schools.

In Plato's *Symposium*, Aristophanes tells how in the beginning, the earth bore dual beings, at once male and female, so strong and bold that they dared scale the heavens to battle with the gods. Zeus became angry and decided to slice them in two, whereupon each being, pining for his other half, threw himself at it, desirous of reuniting with it. Thus love was born.

Most flowers are living incarnations of this myth of a golden age when the sexes were not yet separated. But although these flowers embody both sexes, almost none is capable of fertilizing itself. Sprengel noted early on, "Nature seems indisposed to the pollination of a flower by its own pollen," which Darwin expressed more forcefully, as: "Nature abhors perpetual self-fertilization."

Why this interdiction, when it would seem so simple for the stamen's pollen to fertilize the pistil, only a few millimeters away? Uniting the pollen of a plant with the plant's own ovules is the same as combining strictly identical genetic inheritances. The resulting plant will be only a mere copy of the mother plant. Self-pollination is the enemy of genetic change and innovation. By perpetuating itself exactly as itself a plant eventually condemns itself, for it becomes incapable of adaptation to the shocks and upheavals in its environment.

In the course of evolution, natural selection has favored traits that bar flowering plants from the dead-end of self-copying, and the resulting genetic stasis. Sometimes, the stamens and pistils cannot traffic with each other for reasons of topography; sometimes they mature at different times; and, finally, sometimes it is self-sterility that denies flowers these dangerous liaisons.

If plants consume themselves in bursting into bloom with the colorful and sweet-smelling structures we call flowers, it is to employ them as beacons to attract those creatures who can transport their pollen to other flowers of the same species.

To the botanist, a flower is merely a sexual apparatus imbued with exhibitionism and ornamented with a thousand eye-catching advertisements: outrageously colored flounces, petals, and sepals.

However, it is not our eyes that flowers seek to charm, but those of nectar-gathering insects who insure their pollination. Without them, 80 percent of the plants would disappear from the face of the earth.

For a hundred million years now plants have undergone revolution upon revolution. First they evolved a large flower type, multiplying it endlessly in similar floral creations, like the water lily or the magnolia, structures accessible to the most inept nectar gatherers; then came such highly differentiated flowers as the buttercup and the geranium, which divide their reproductive functions between sepals and petals; later appeared the narcissus, gentian, honeysuckle, and other flowers whose tubular corollas allow their nectar to be reached only by butterflies equipped with a long, tapering proboscis. Finally came such highly sophisticated flowers as orchids and sage, whose subtle modus operandi only honeybees and bumblebees can master.

Thus over the course of time flowering plants have often modified their appearances and styles, and insects have responded to these developments with developments of their own. So closely have these creatures linked their destinies that it cannot be definitively established whether an insect or a plant initiated a change.

In the end, what I write here cannot explain the mystery of flowers, for their magic cannot be captured in an enumeration of parts and functions.

One can approach the nature of flowers only circuitously, poetically, even voluptuously, in the manner of bees. Perhaps the spectacle of flowers is so overwhelming that we want to bring it back to earth by consulting botanists. But what botanist's vocation does not spring from the sense of wonder felt before the beauty of mystery of flowers? Scientists are both passionate and prudent. They erect around their emotions a bastion of universal rationality.

Will we ever know why flowers—which, as we now know, deploy their charms to appeal to insects—have such a hold on us?

The beauty of flowers does not exist to please the aesthetic sense; it requires no assent; it sets itself above judgment, with a tranquil obliviousness.

To gaze at flowers is to plunge into the center of the world, and through the proliferation of forms that overwhelm us there, to discover how much we belong to the world. If our eyes light up at the sight of shells, blades of grass, or clouds, it is because the eye is made of the same fabric as they are, constructed out of the same constellations of atoms; the eye is part and parcel of the same elaborate dance of forms, and driven by the same forces of the universe.

Put another way, the eye is made to wonder, just as the flower is made to bloom.

C. N.
LA CARDINELLERIE
JUNE 1997

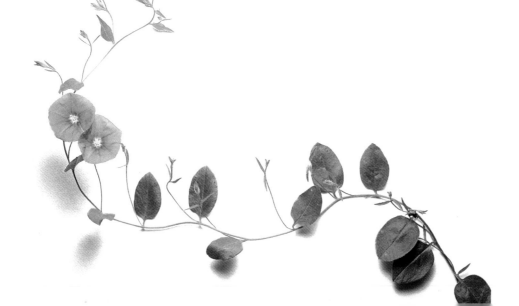

The flower is a leaf mad with love.

GOETHE

Cornflower

The cornflower isn't just a flower, it is a bouquet. This worthy representative of the great Compositae family joyfully plays the pluralist politics of its group. Instead of opening a single flower with a large corolla blooming at the end of each stem, it produces a society of blossoms crowded together on a common platform, the capitulum, at the top of a number of tiny stems. Together, these minicorollas create a gorgeously appointed composite flower that attracts nectar-gathering insects.

Dandelions, thistles, and daisies resort to this same strategy of accumulation. But the cornflower is not content with merely amassing similar flowers. Around the edge of its bouquet, a dozen large sterile corollas encircle the mass of florets in the center, thirty small hermaphroditic blossoms standing side by side. The sterile blossoms at the edge play the flirtatious role. They are floral publicity agents, so to speak; their vivid color attracts insects from far and wide. The more circumspect blossoms of the flower produce the seeds and actually propagate the species.

Before bringing out its finery, the cornflower's unopened bud is an oblong citadel, armed with scales set around it like the sides of a jewel casket, which encloses the floral buds within like a treasure. Suddenly, the upper part opens, allowing a jumble of intertwined petals to shoot up like a blue flame. The next day, the flower has opened completely. Bees are its most assiduous visitors. Ultraviolet rays of the sun, invisible to our eyes but which bees can detect with a singular acuteness, are ably reflected by cornflower blossoms—well enough, at any rate, to catch the hive dwellers' notice.

As soon as its florets are fertilized, the cornflower abandons its finery. A shaggy mop—the faint blue remains of the faded outer blooms—tops the stalk. The leaves growing at the flower's base—the bracts—close. Then, after a few days of maturation, the bracts open like a bowl, releasing to the wind a collection of elongated pearly white fruits crested by short, pink-tufted plumes.

All flowers appear to me as if coming from afar,
like news for which one hopes against hope.

ANDRÉ DHÔTEL

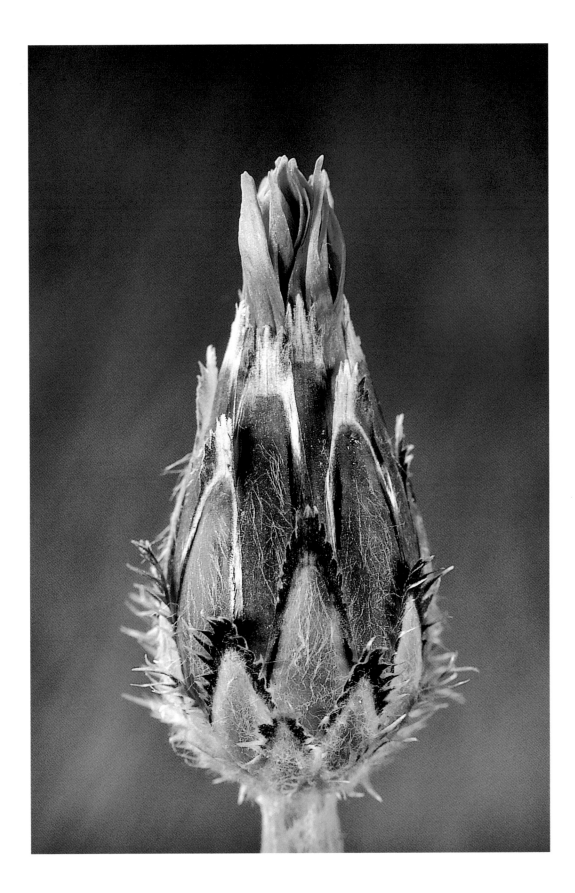

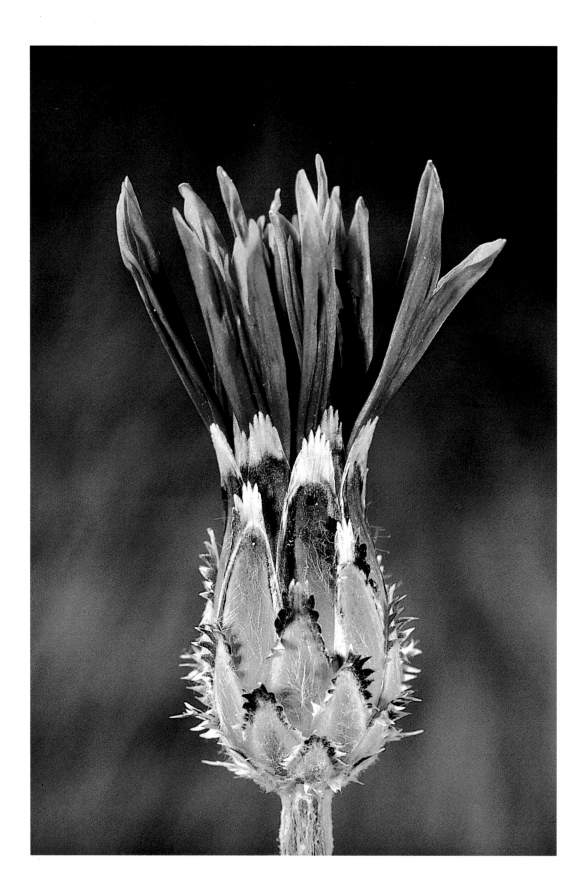

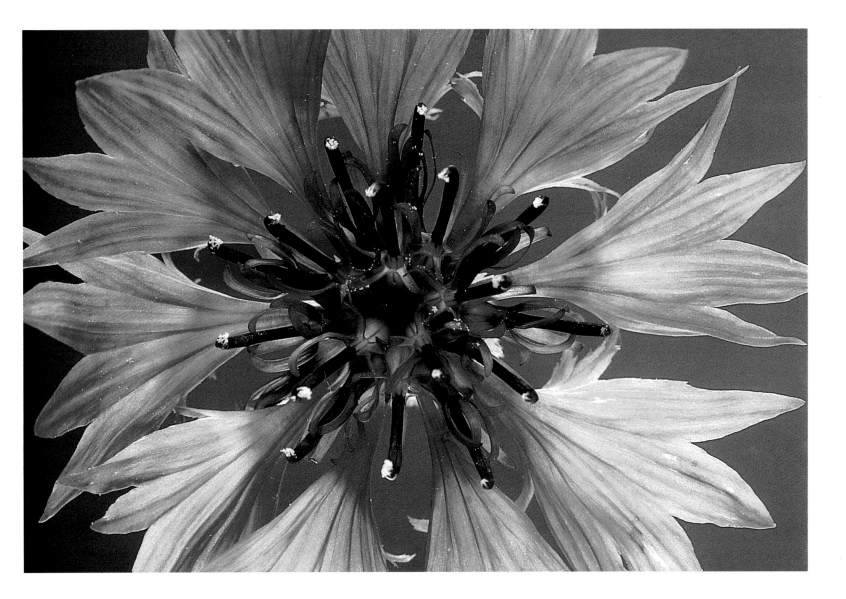

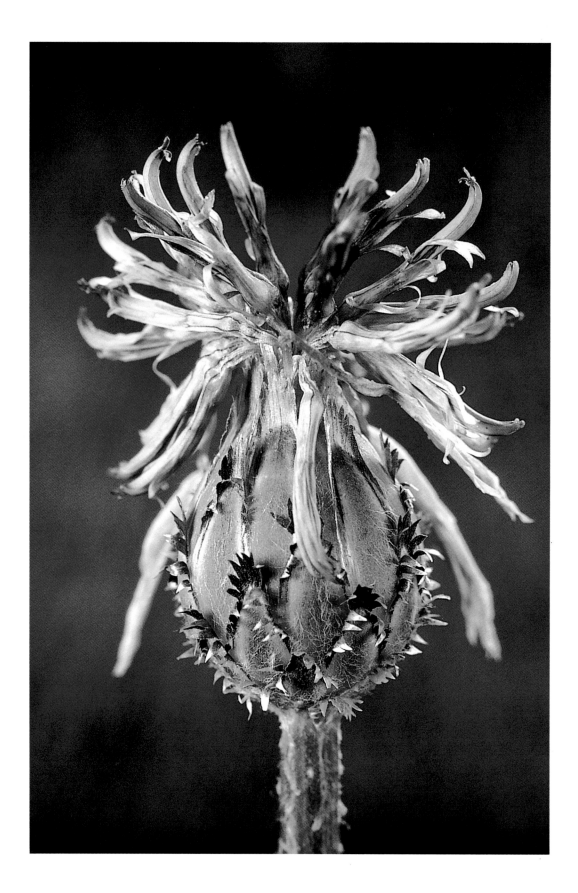

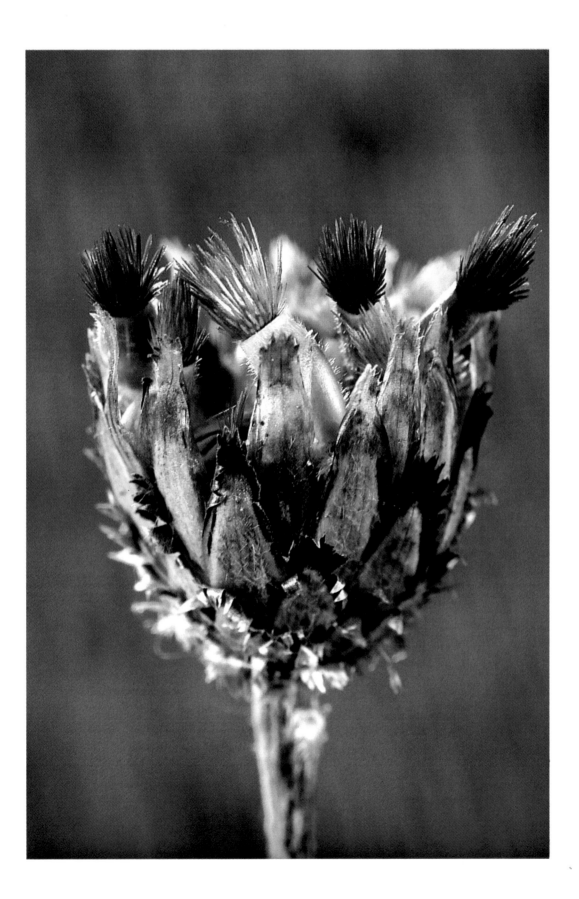

Hartwort

\mathcal{A}t the moment of its blooming the hartwort lifts a fragile, pale rose doily to the sky. Bordered with festoons, the flower resembles old lace. Not much to attract the attention of a casual passerby, but if we stoop to consider this obscure inhabitant of uncultivated grounds under a magnifying glass we perceive its full-blown corollas as a blossoming nebula.

The hartwort knows well the craft of constructing audacious floral architecture. Its stem, fluted like the columns of Greek temples, is divided into a base and about ten diverging spokes that evoke the armature of an umbrella (the name of its botanical family, Umbelliferae, comes from the Latin *umbrella*, "parasol"). At the beginning of this century, the great Catalan architect Antoni Gaudí conceived of revolutionary columns with multiple capitals as supports for the ceiling of the (unfinished) Church of the Holy Family, in Barcelona. He was doubtlessly inspired by plants.

The hartwort's sophistication extends even farther. Each of the ten spokes in turn engenders ten smaller branches, like the successive bursts of a fireworks display. And this forest of pillars explodes in a myriad of corollas, a compact swarm of vegetal stars. These closely packed, tiny flowers are an ideal platform for the landings of nectar-gathering insects.

Far from practicing a rigorous selection among its visitors, as some plants—the sage, for example—the hartwort offers up its nectar to flies, bees, and butterflies alike, buzzing crowds that guarantee pollination.

The hour of blossoming arrives. Grace gives way to heaviness, for in respect to dissemination the hartwort's hardy fruits hold no trumps. Unlike both the wild carrot, which sends out its hooklike seeds snagged in the fleece of passing animals, and the angelica (also an Umbelliferae) which expedites hers on little winglike membranes well suited to lateral flight, the hartwort submits to the tyranny of gravity, that is, it drops its seeds at its foot.

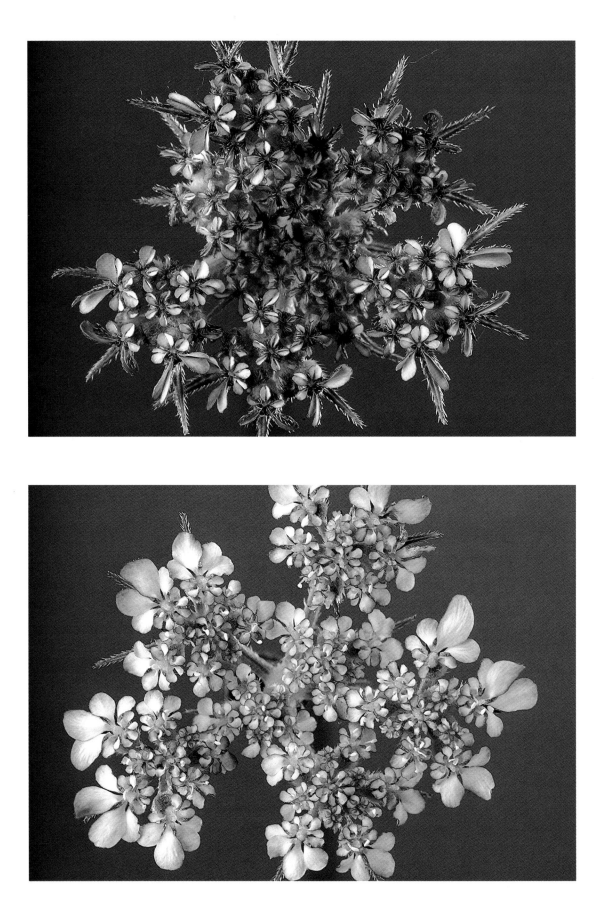

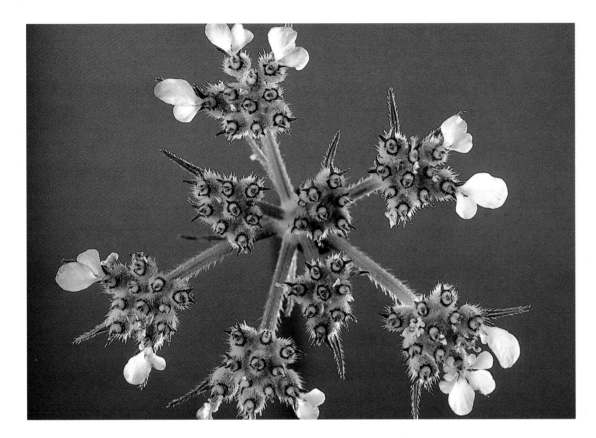

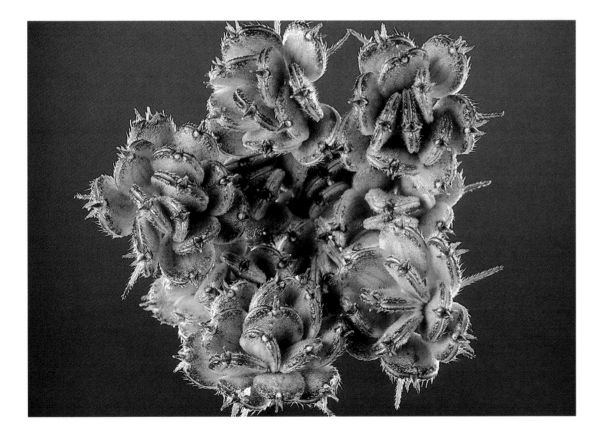

Poppy

Behind its graceful silhouette the poppy conceals the character of a conqueror. Beginning with the first agriculture in the Neolithic period, the poppy was carried like a stowaway in cereal sacks and sown along with the grain, following humanity on its migrations, spreading from one culture to another across the inhabited world.

This living battle flag begins its career quietly, the young flower bud modestly bending its neck over the ground. When it at last lifts its head toward the sky, two green sepals felted with tiny purple hairs snap off at their joints. A riot of scarlet folds and counterfolds presses these now-freed pieces toward the top of the flower, where, finally, they crown the rumpled petals with a rakish hat, something like a toque with earflaps.

Like a magician pulling a seemingly endless piece of cloth out of a thimble, the poppy unfurls an ever-expanding corolla. It takes several hours for this fabric to smooth out all traces of its wrinkling, for the several weeks that it has spent bunched up in a tight place have crumpled the petals considerably.

The poppy flower has no scent and secretes no nectar. But it spends its pollen lavishly: a hundred-stamened spray covered with yellow powder welcomes visitors, and from the very first morning of bloom poppies are plundered by bees. Their landings are hazardous: with the fluttering of an insect's wings, the flower, perched atop a flexible stem, often slips out from under the insect at the last moment.

And indeed, by evening the beautiful ornament breaks up. Petals and stamens fall to earth so that the central pistil, now turned into fruit by pollination, stands alone. As it dries, its inner walls contract and open a series of small orifices beneath its festooned hat; whenever the stem trembles in a wind, a flood of minuscule seeds streams forth from these perforations, thanks to which future harvests will see the kindling of new scarlet flames.

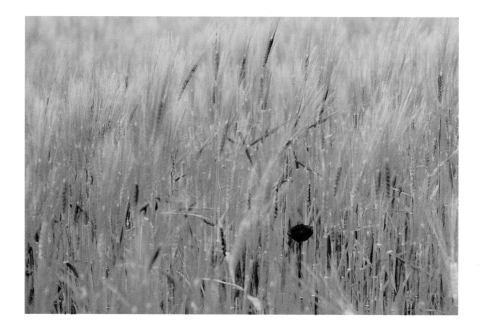

*You willingly acknowledge some possibility of angels' existence because they
have the tact to stay invisible. Or you feign to believe in them and it is easy
to deny them, whereas a poppy, an oak or a service tree [sorb] has the effrontery
to affirm, with insupportable evidence, the presence of an impossible dream.*

ANDRÉ DHÔTEL

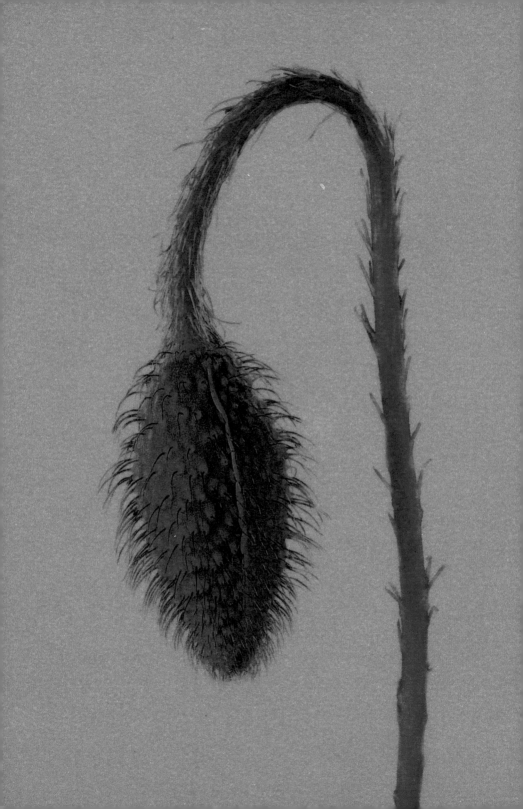

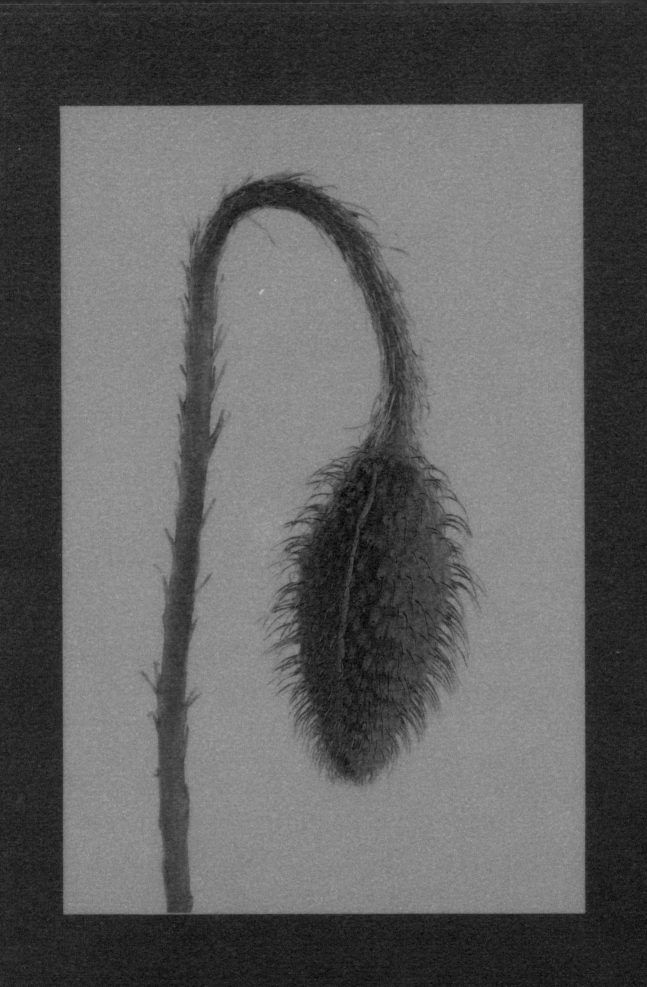

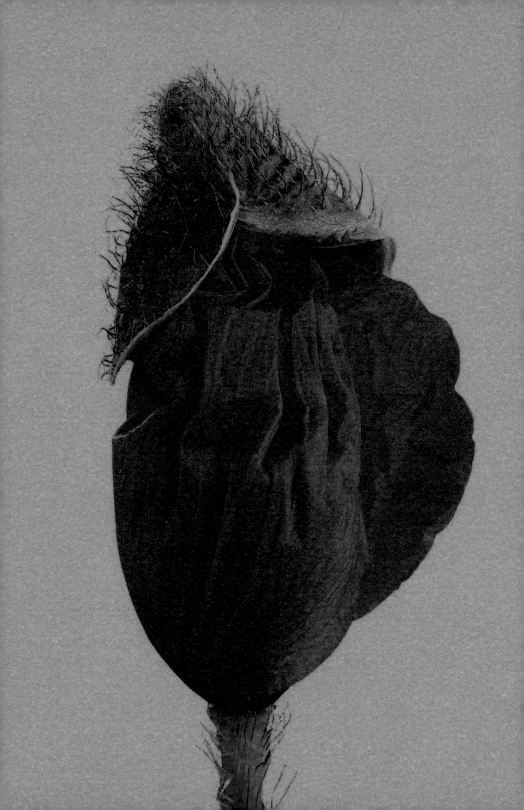

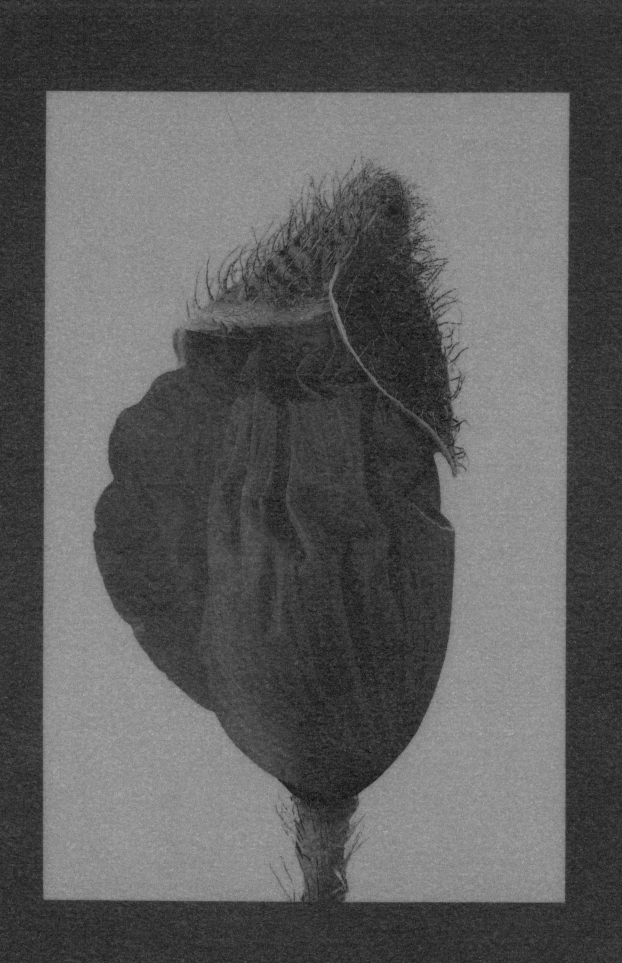

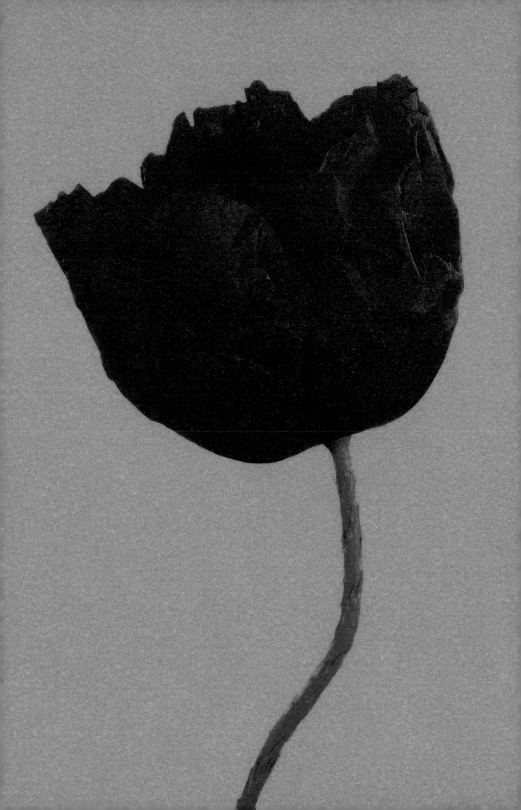

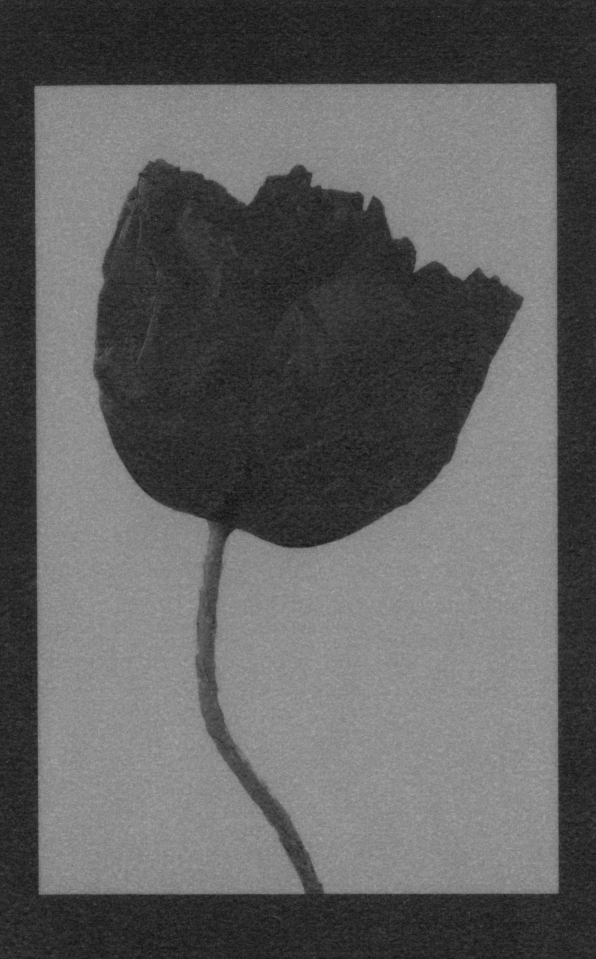

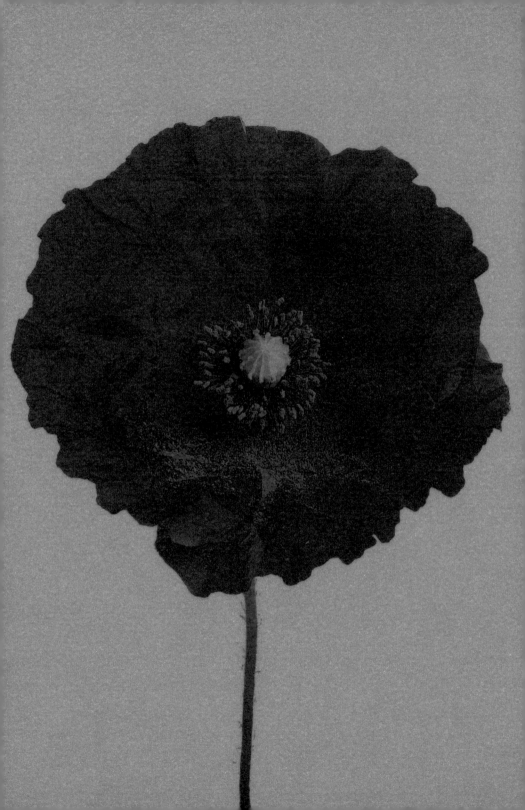

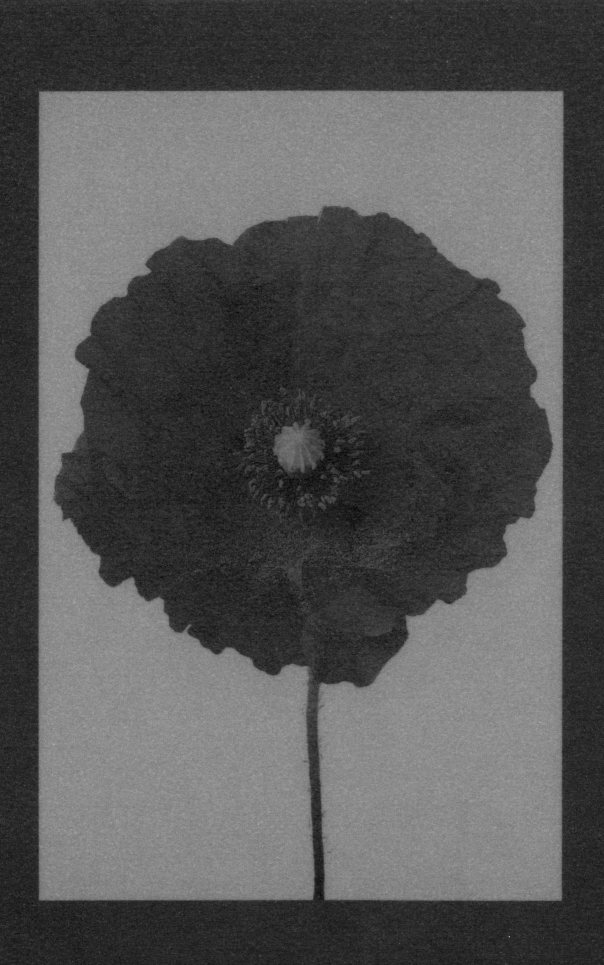

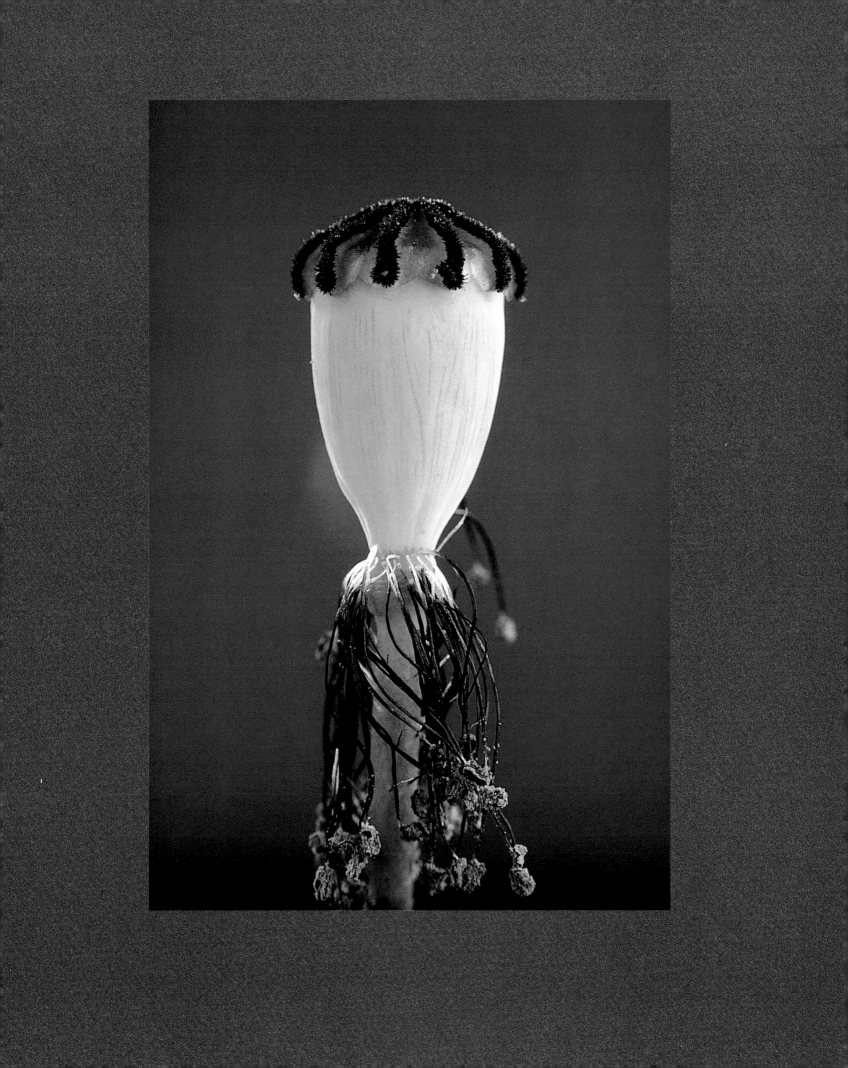

Fallen eglantine petal in the grass.

Eglantine

In continental Europe the eglantine is called by such names as dog rose, pig rose, devil's rose, witch rose, mad rose, surprisingly unkind words for this noble flower. But why? Is there some fear of nature that people feel a need to insult wildflowers? Is it such a sin to be beautiful with a beauty not derived from the horticulturist's skill? My own garden accommodates many duly pedigreed rosebushes but none more delightful than the eglantine bushes that had taken root there long before I came.

Even in its infancy the eglantine has jewel-like aspects. The flower bud stands like a princely helmet, extravagantly winged and set with blazing rubies. Rarely do sepals, which are usually only supporting actors on the great stage of a flower's blooming, exhibit such decorative excesses.

When these five baroque leaflets withdraw toward the base, it is to bare to the sun the very archetype of a corolla, a classical ideal of a flower: a bowl lightly tinted with a delicate, watercolor pink, which, in the center, yields to an off-white splashed with the stamen shower's yellow gold.

The eglantine is a hospitable flower, perhaps too hospitable. Its corolla is offered up to all plundering insects. Even if bees respect flowers, the fat, heavily and clumsily moving Cetonidae—beetles clad in an iridescent green armor—tend to confuse pollination with havoc. Although we can have no doubt about their function as pollen carriers, we can still bewail the beetles' penchant for nibbling the petals of their host.

The result of their revels? A paunchy rubicund fruit, smooth as enamel, coated with a score of seeds. Nicknames for it are as rude as those for the eglantine itself. How curious that such a handsome plant should set off such an ill-tempered round of name-calling.

A rose has no why or wherefore; it blooms because it blooms,
has no concerns outside of itself and doesn't seek to be seen.

ANGELUS SILESIUS

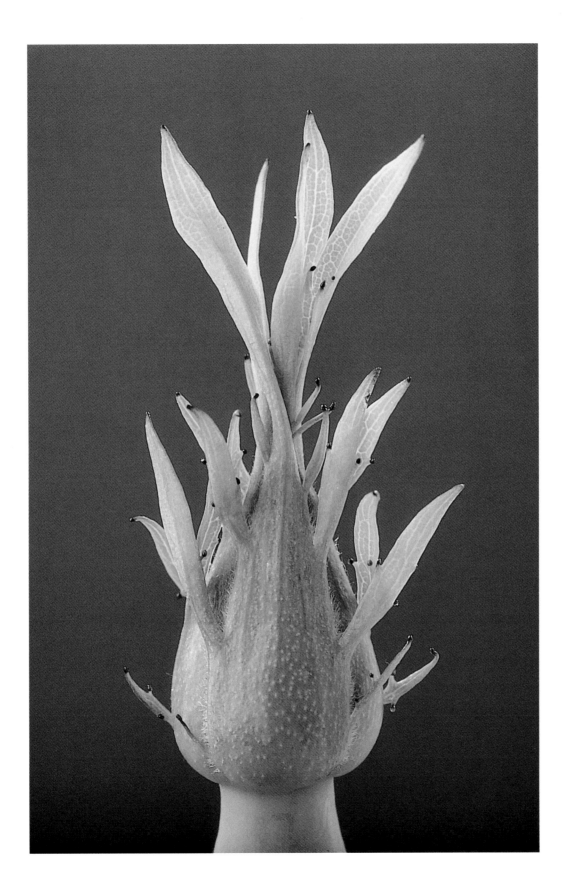

45

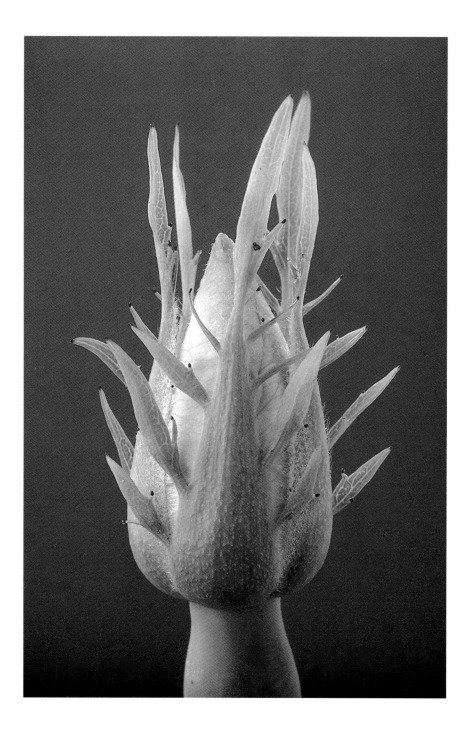

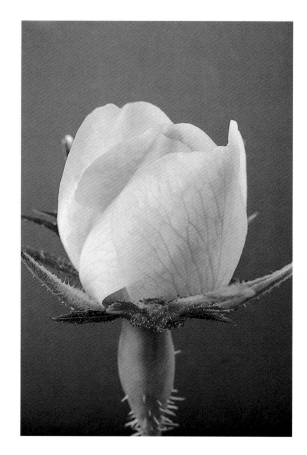

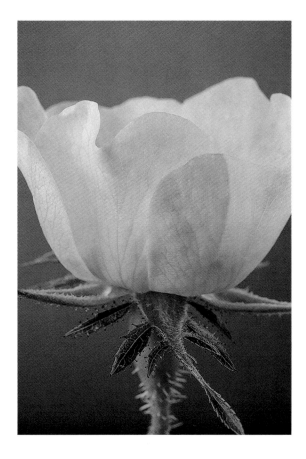

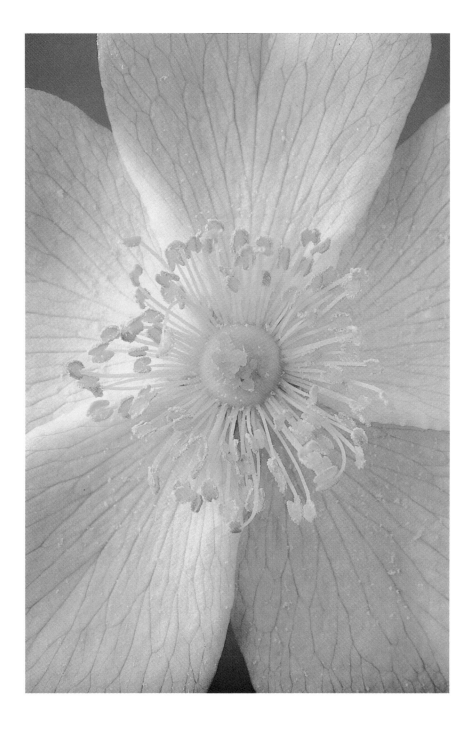

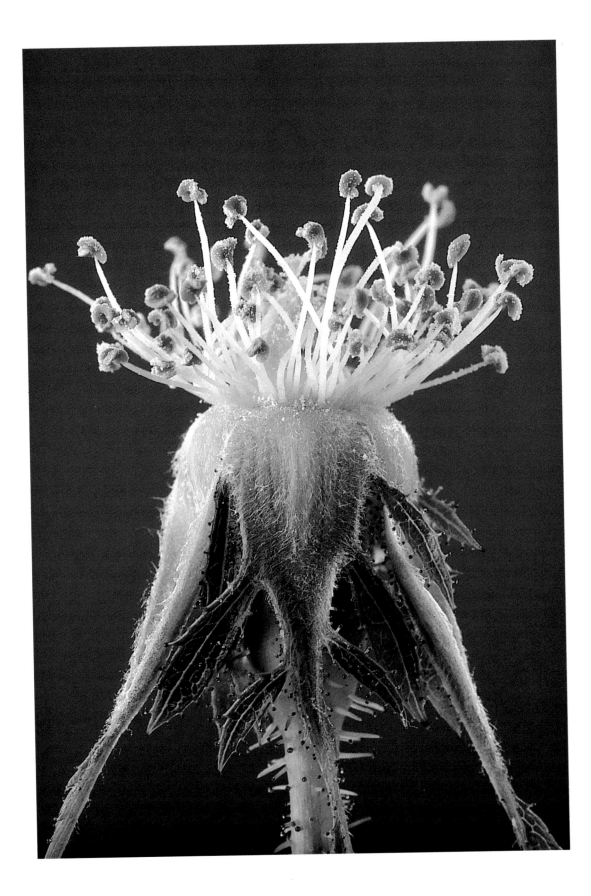

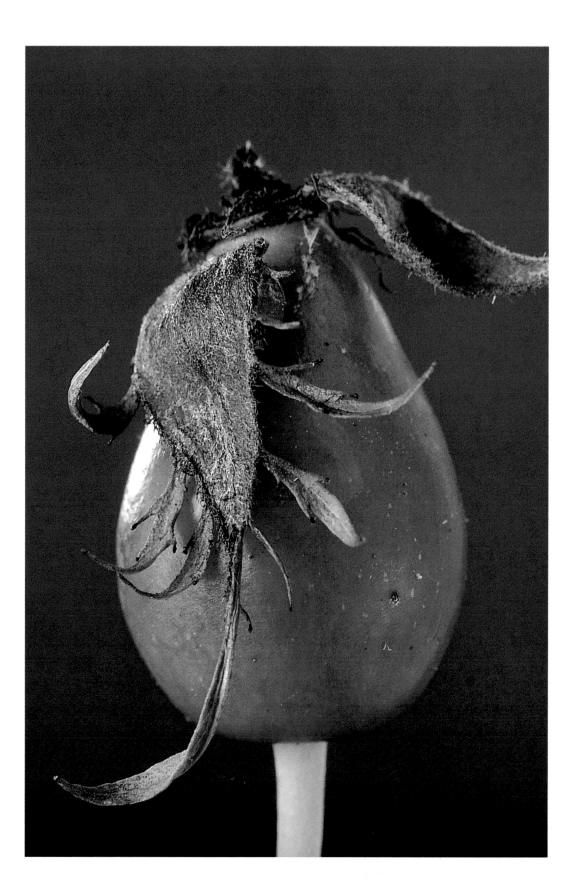

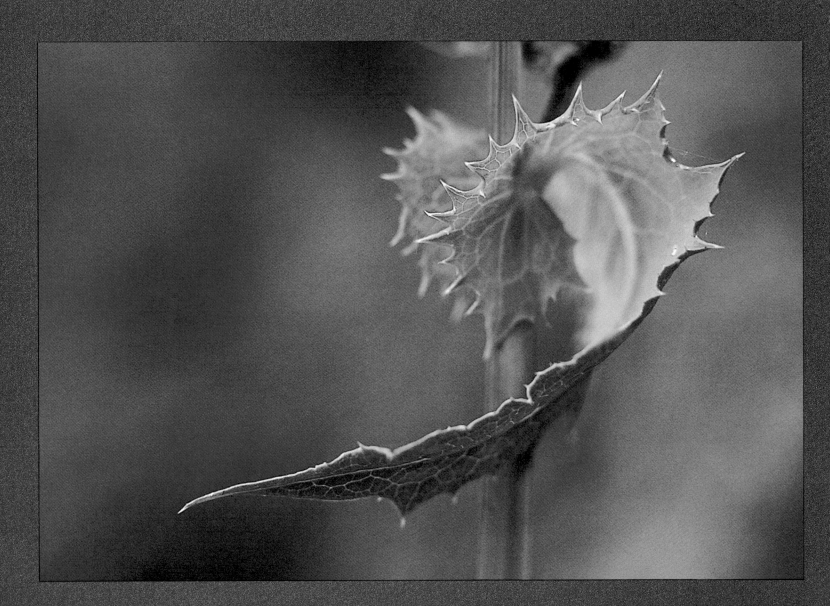

Thistle

Faced by animal peril—for many a flower disappears into the jaws of herbivores—the thistle has opted for an armed peace. It's a living object lesson of dissuasive tactics. Stems and leaves bristle with sharp points enough, but the plant redoubles its fortifications around its flower. Multiple rows of thorny bracts, tough narrow leaves, are thrust in every direction, like so many daggers guarding the young bud's security.

But at its top, this stern armor—which shows not the tiniest chink—breaks up its line of defense and gives way to a delicate pompom, thick as a brush, soft as velvet, and of an affecting pink violet in contrast to the thorny armor below.

It hardly seems right to use the singular and speak of the thistle *flower*, for like all members of the Compositae family, its bloom is plural. Thistles subscribe to a collectivist floral politics. Each of the colored tufts that crown the plant numbers a hundred or so tiny tubular flowers, all lined up, as alike and closely set as toy soldiers. Bumblebees and butterflies, armed with long tongues, are the only visitors who can manage to drink from these nectar flutes.

At the end of efflorescence the plant regains its stern demeanor. Each head wears battle plumage that, little by little, becomes progressively sparser each day in direct proportion to the number of tufted seeds covering it—which eventually mingle with the fur of passing animals and so travel, as it were, on back of the enemy.

The thistle represented here is an *Onopordon*. The only ruminant with a mouth tough enough to graze on this vegetal hedgehog is the donkey, and even this rough-hewn beast pays for his audacity with minor intestinal discomfort.

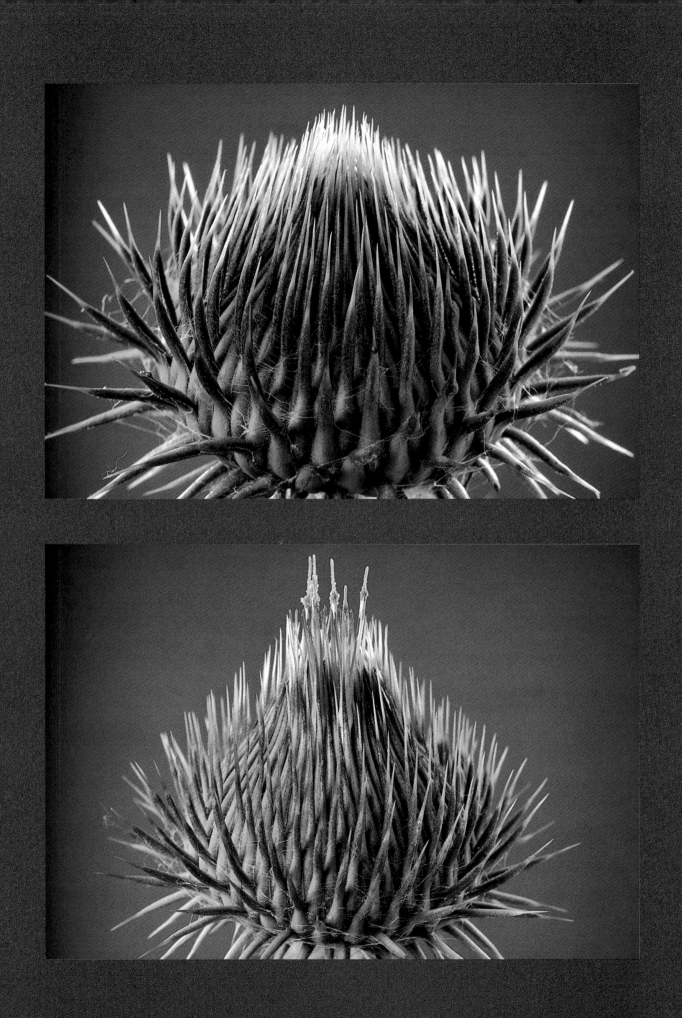

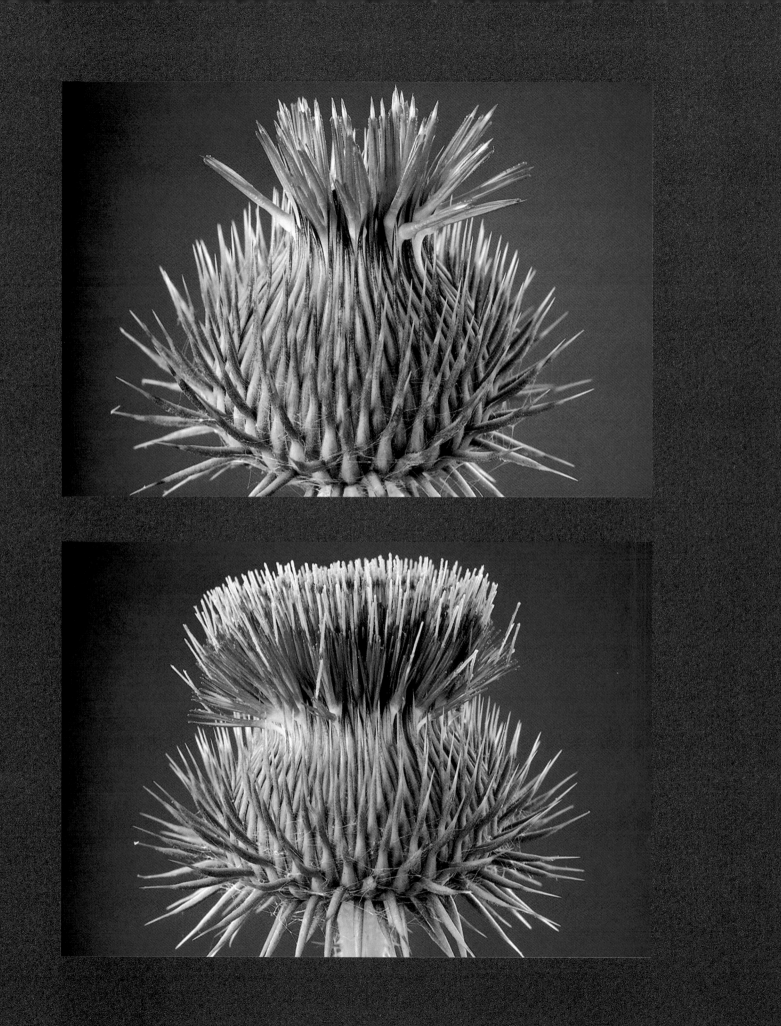

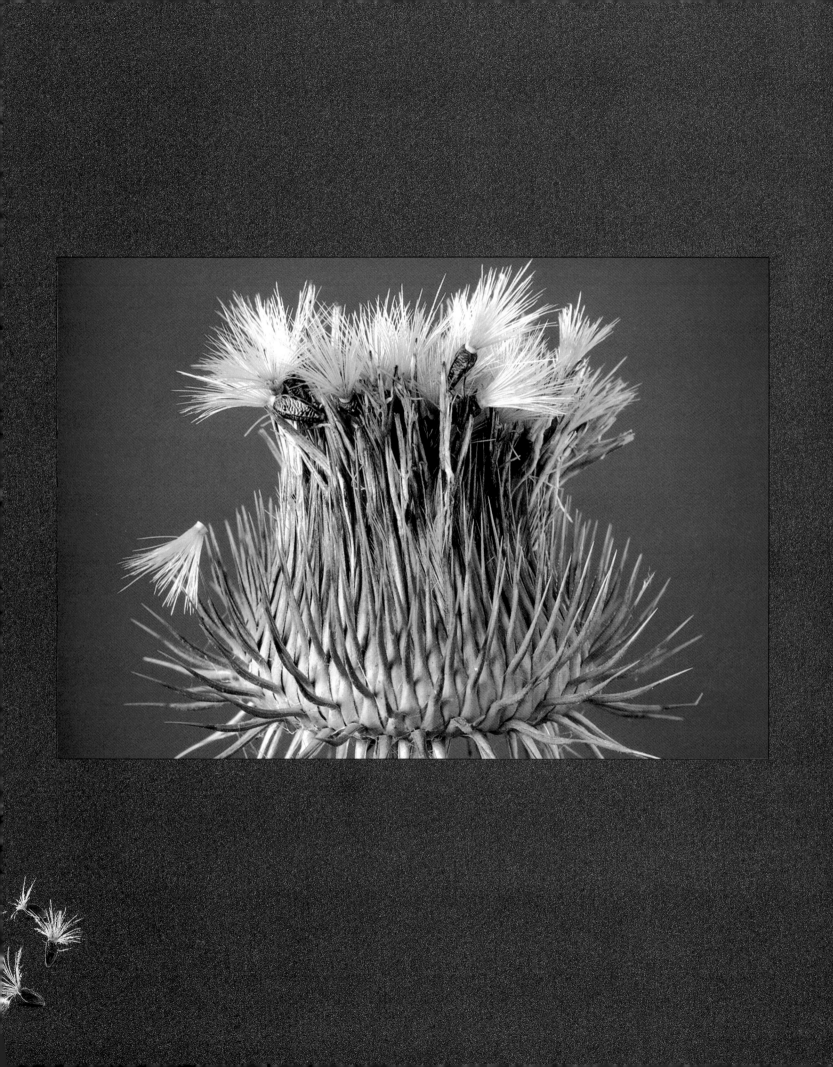

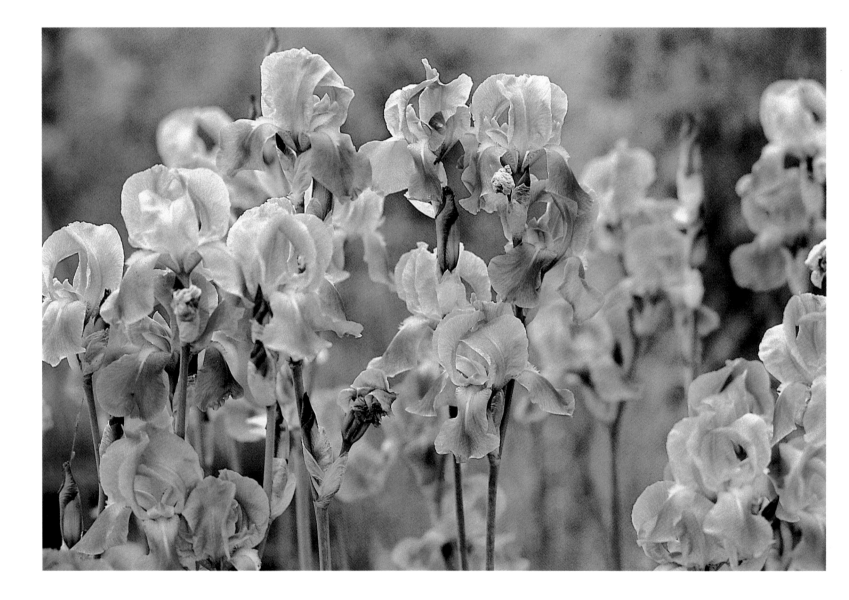

Iris

Before committing its forces to a blazing moment of flowering, the iris shows only a discreet fan of sabrelike leaves sheathed within one another and pointing directly toward the sun, leaving not a glimpse of stem.

In the spring the flower abandons this retiring posture. A floral stem about a meter tall shoots up from the heart of the leaves, bearing a dozen or so flower buds, each emerging long and pointed from a wrapping of translucent cornet of tissue. These membranous bracts protect the young buds as they begin to develop.

Within the bud's confines the flower parts are organized to make best use of the limited space. The three accordion-pleated sepals are wrapped around each other in a coil that suggest a stilled whirlpool.

As the flower opens, the sepals bend toward its base while the petals buttress each other, covering the flower with a purple baldachin. All the flower parts, including the stigmas (the pistil's uppermost parts) are delicate veils and wings shot through with nervation, forming a dream castle with three vestibules.

What visitors discover the entrances to this princely abode? Bumblebees, who dash down through the fine brushes of golden nectar garnishing the sepals. In reascending this sweet-smelling path they slip beneath the stigmas' blades. Their girth is ideal; while passing through, their hairy backs graze the stamens and thus load up with pollen.

Its office discharged, the palace collapses. At the top of the daily swelling fruit there soon remains no more than a horny brown tuft, the sole vestige of days of splendor.

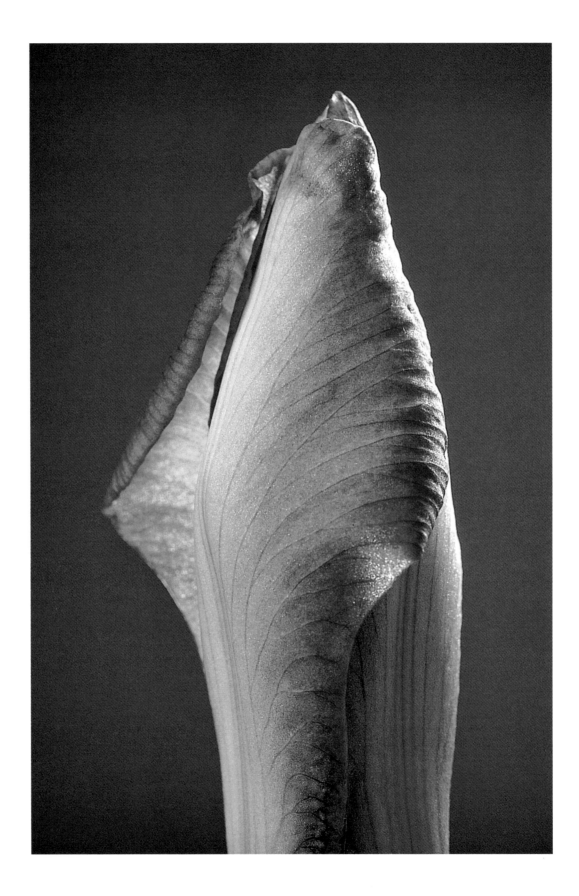

58

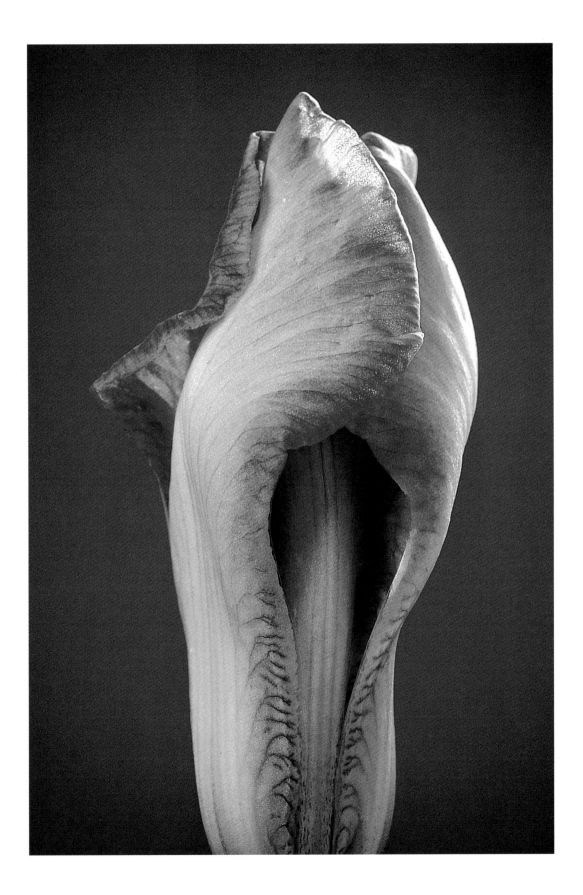

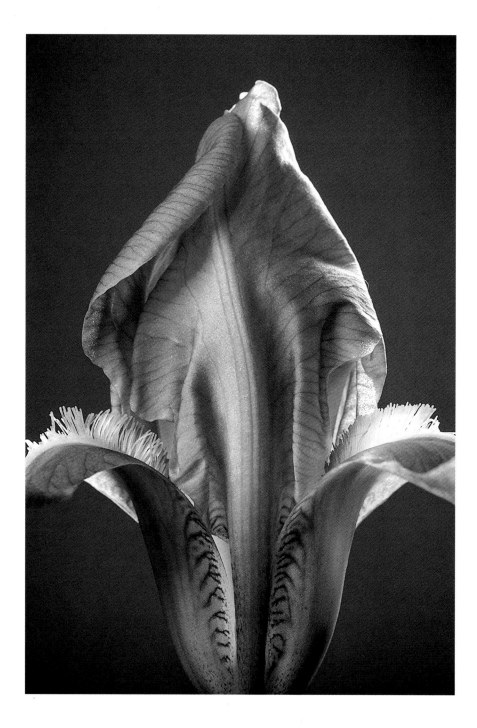

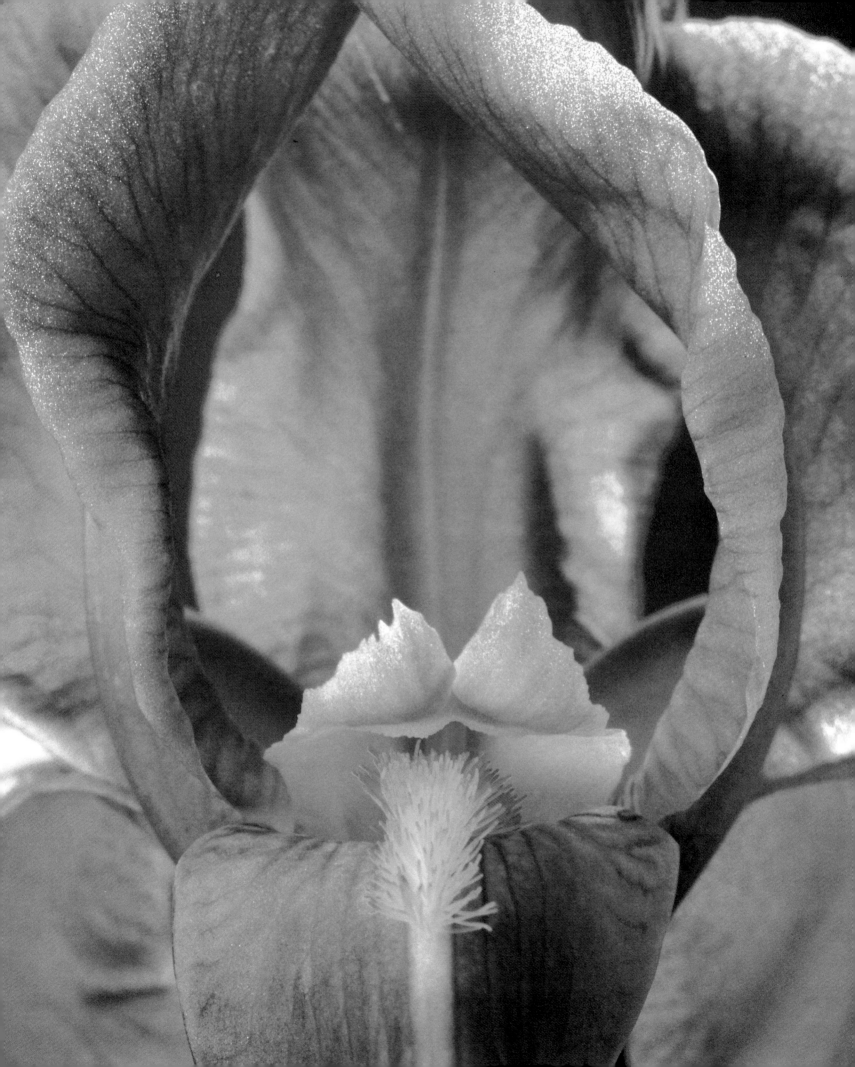

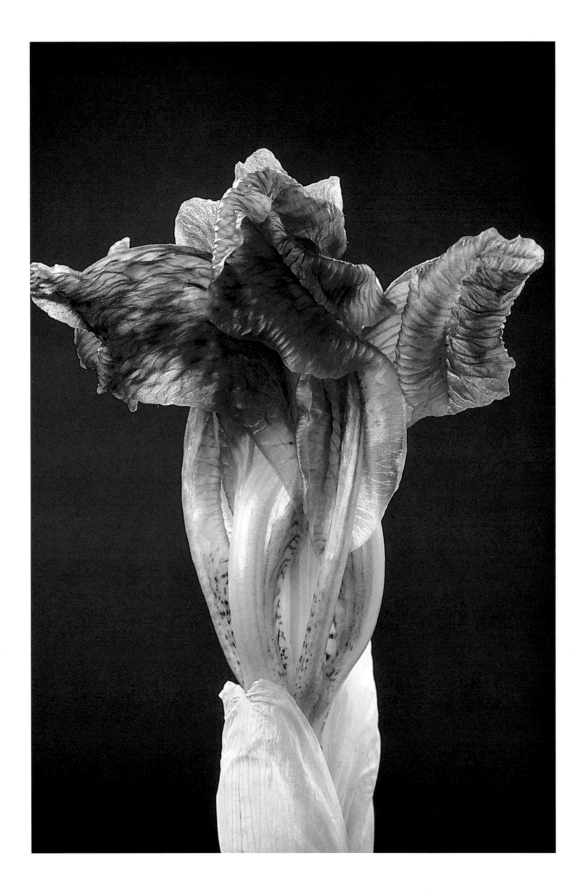

I believe a leaf of grass is no less than the journey-work of the stars,
And the pismire is equally perfect, and a grain of sand, and the egg of the wren,
And the tree-toad is a chef-d'oeuvre for the highest
And the running blackberry would adorn the parlors of heaven. . . .

WALT WHITMAN
Song of Myself, XXXI

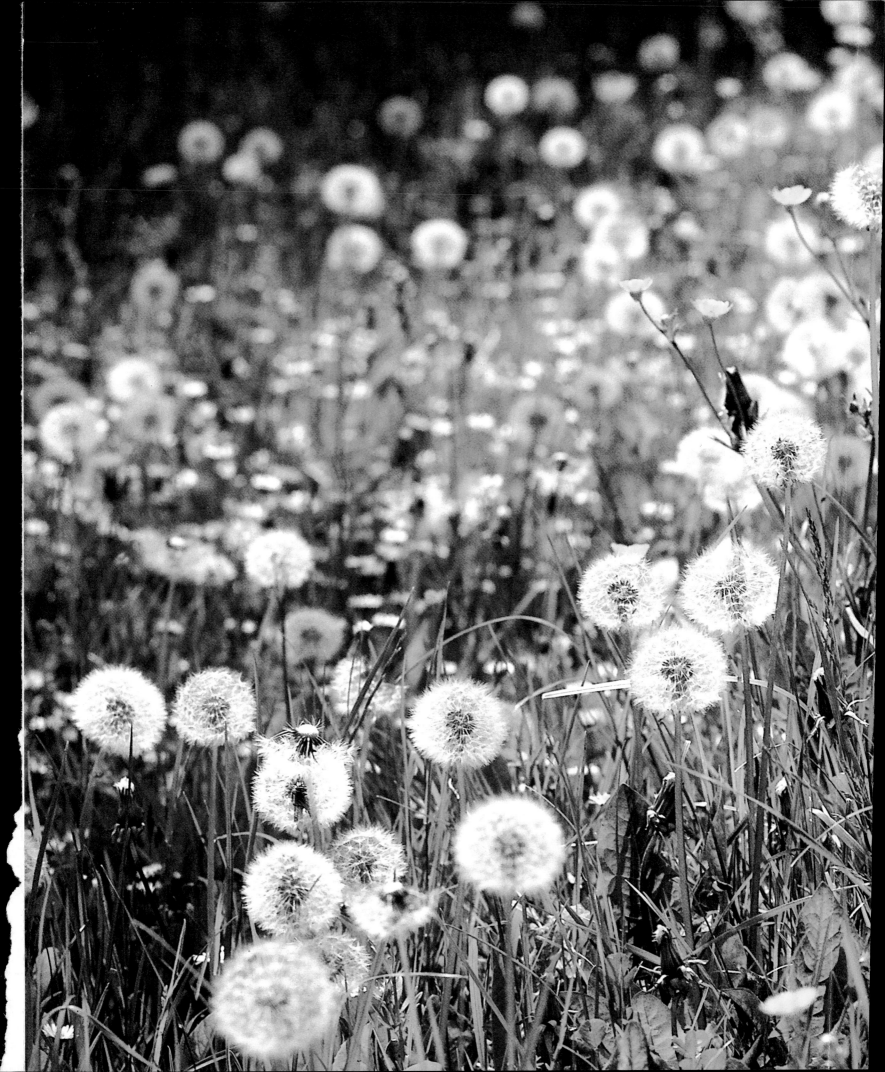

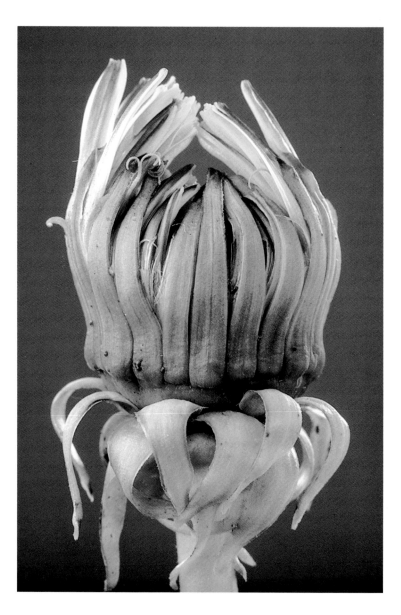

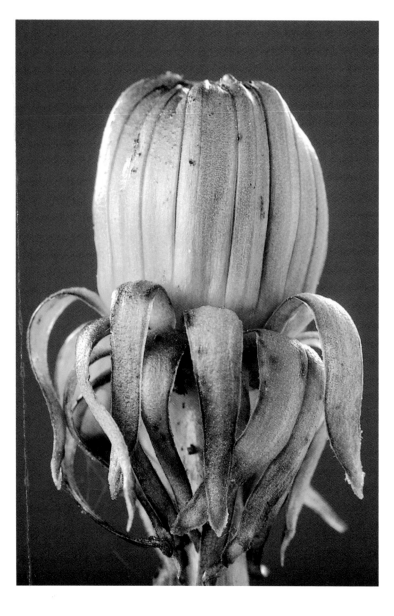

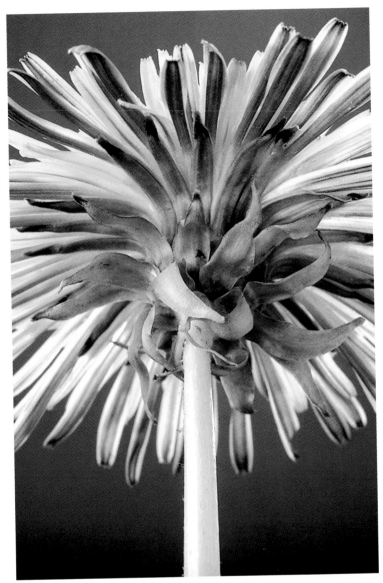
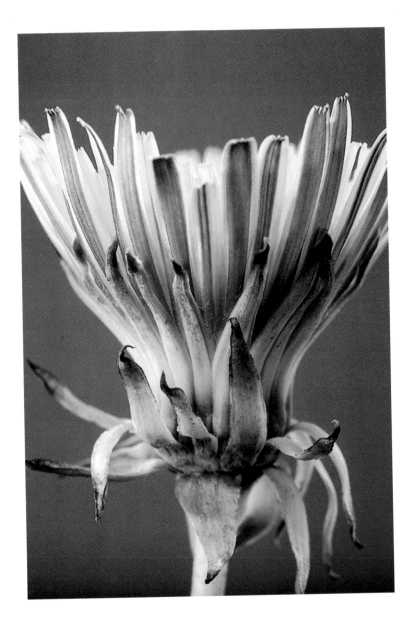

Dandelion

There is nothing more commonplace than the dandelion. Does it deserve a place in our floral biographies? If you think a common plant cannot astonish you, I would recommend that the reader look closely at the dandelion, not merely in passing but with regular visits to the same clump, many times a day, in the mornings above all, for two weeks. You will find it a precise and effective tonic for boredom.

In fact, the dandelion is part of the great Compositae family (considered, along with orchids, the most evolved of the vegetal world), an honor that it shares with the cornflower and the thistle, which the reader has already met. The capitule—for thus we call the head that carries the set of florets gathered together—is, first of all, armed with tightly joined green bracts, a row of outer scales covering the flower's base in pleasant disarray.

When the bracts open they unveil a miniature star of incandescent yellow. When evening falls, the shutters close and conjure away this blazing apparition. For a stretch of three to four days the dandelion rises and sets thus like a star, if the weather is fine.

One morning the shutters stay closed. Emerging from the bracts, the inter-twined corollas form a dry, dusky yellow hood that drops off in the first breeze. A few more days of closing for the sake of redecoration, and then, the Grand Finale. The bracts rock open and shut one more time and, like a peacock spreading its tail, the dandelion slowly releases a milky way of tiny stars inscribed within a perfect sphere—so many seeds, each carrying an umbrella-shaped aigrette.

The dandelion's aigrette represents perhaps the most successful model of vegetal aeronautics. Indeed, in the middle of the last century the English inventor Sir George Cayley proposed it as a model for the design of a parachute for human use. But where does this feathery tuft come from? It develops from the modified sepals that can be seen quite clearly when the plant blooms, folded around the flower's base like long stringy loincloths. The vegetal world is expert in such reconversions.

When the dandelion's seed-umbrella opens, the spectacle is like a sunrise. If you wish to see it, do not linger too long at home, or the early morning wind will leave you only bald stems to admire.

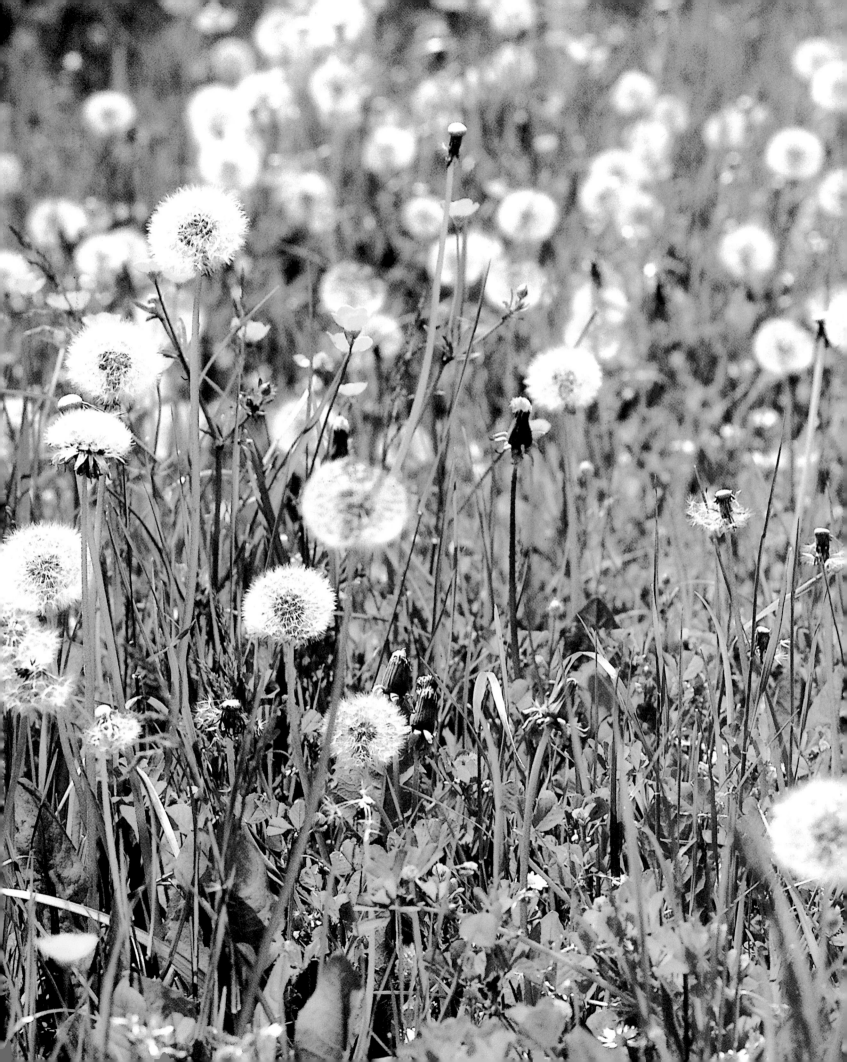

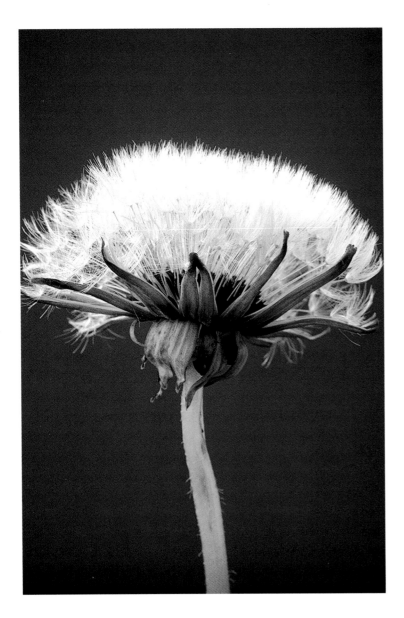

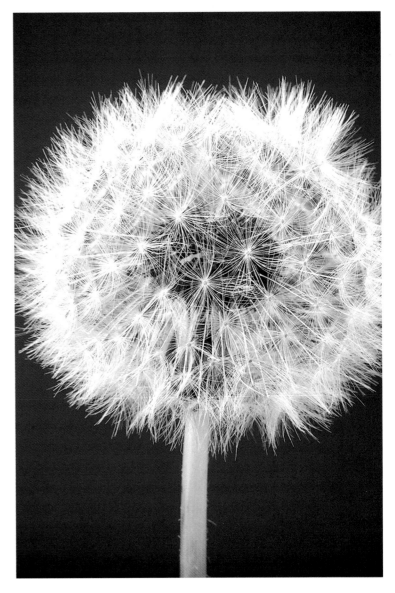

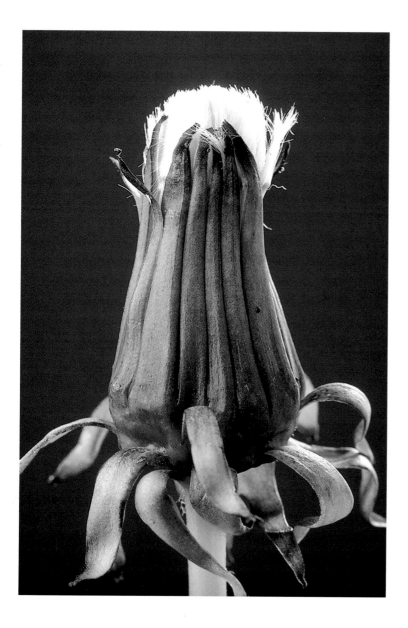
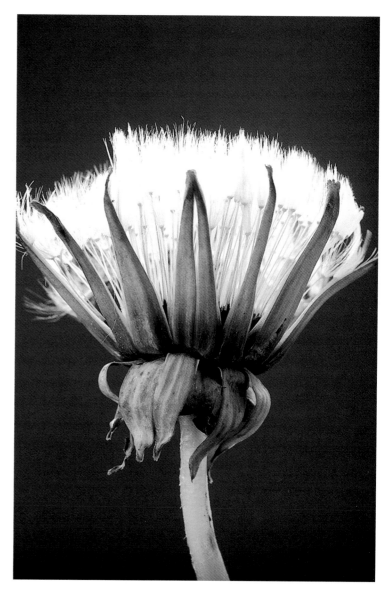

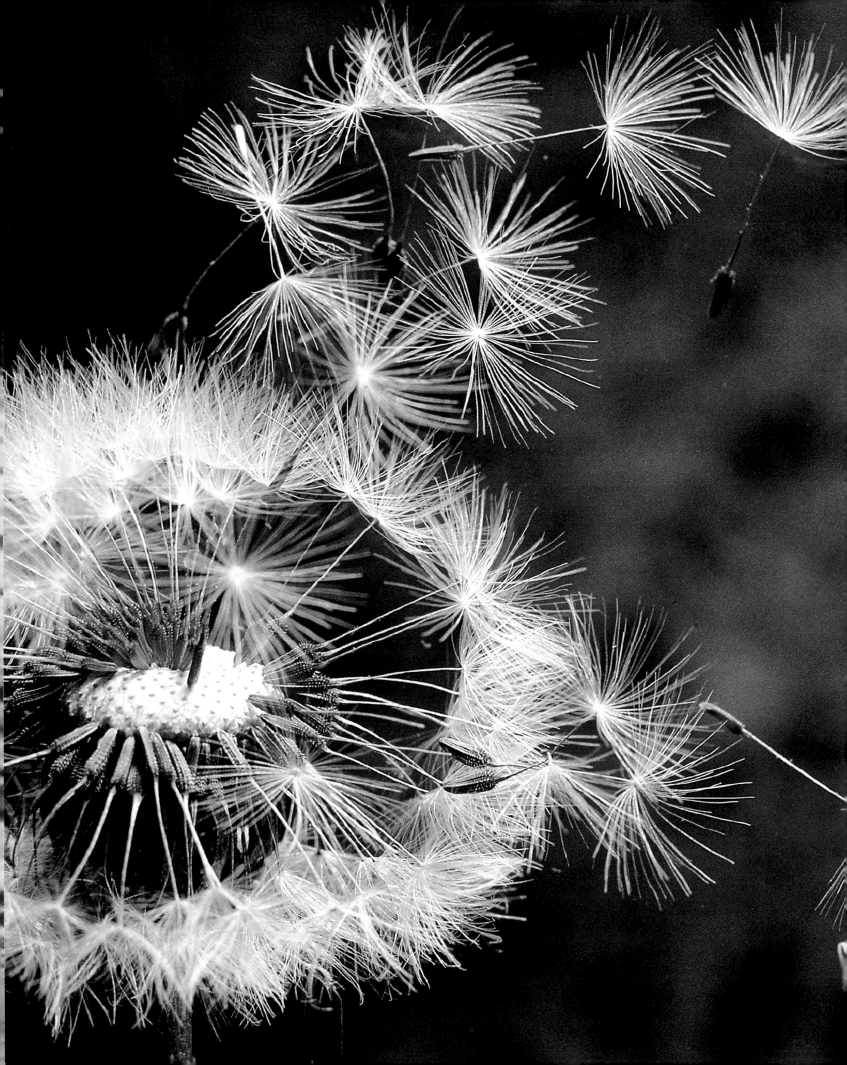

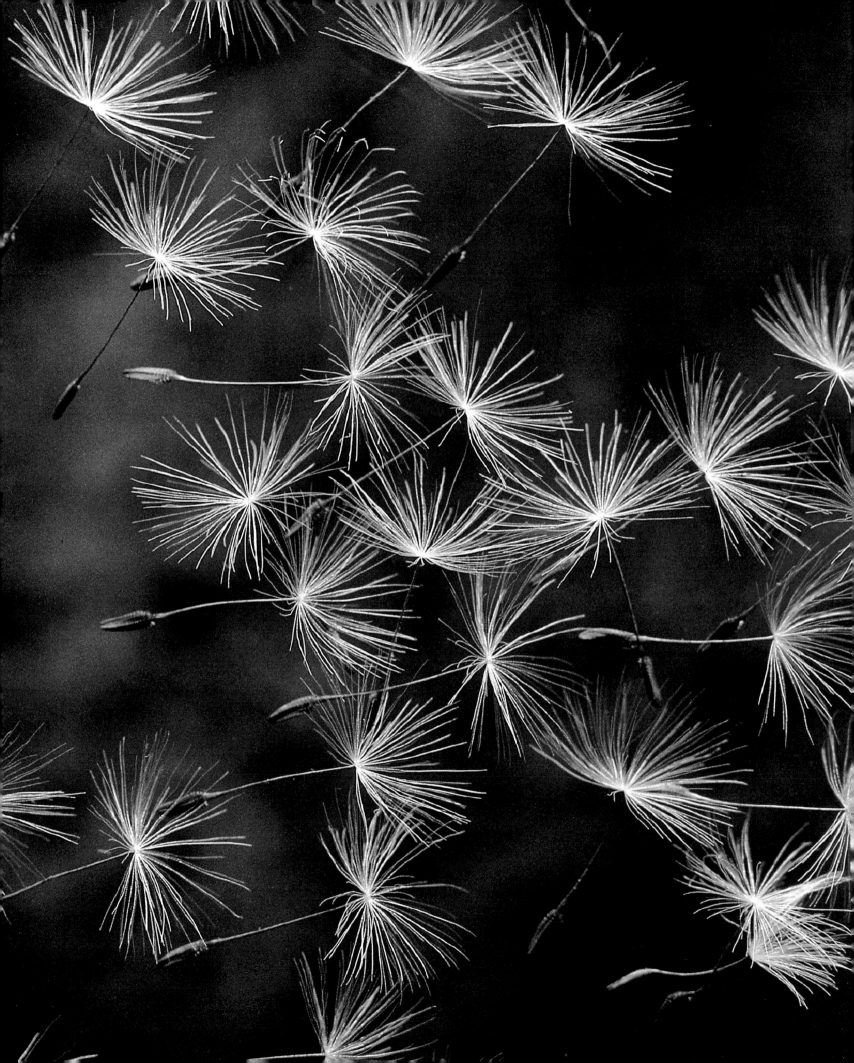

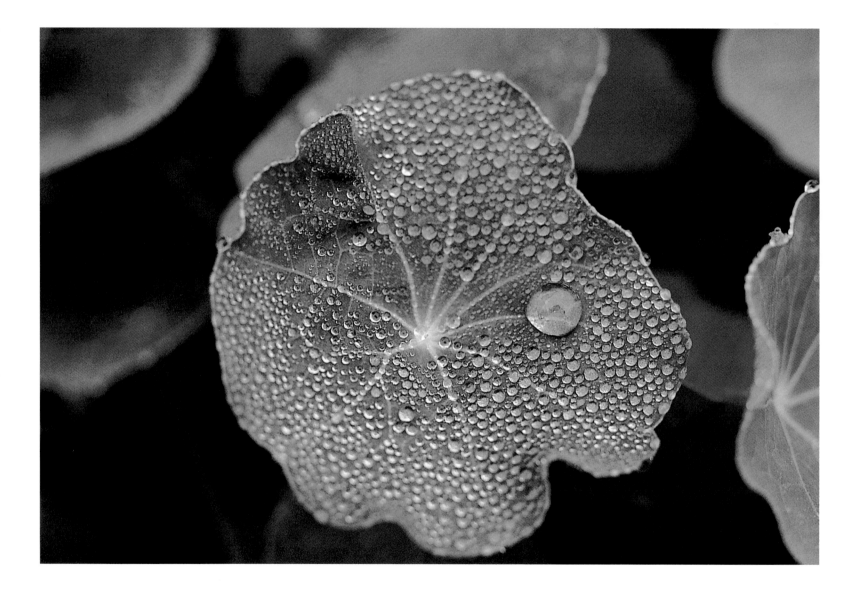

Nasturtium

This is a flower with a face, a profile, a silhouette—as though it had stepped out of an old engraving. The young buds are partly covered with a pointed hood like that of capuchin monks, from the flower's French name, *capucine*, is derived.

As this hood yields to the pressure of the petals opening, an orange muzzle thrusts laterally out, and soon the flower's whole face appears: three petals with fringed bases, topped by two petals with converging stripes, forming a capacious porch of princely colors.

If there are liberal flowers, like the hartwort, which indiscriminately offer up their nectar to all sorts of gatherers, there are other, more elitist ones who practice a strict selection among their guests. The nasturtium is one of these: one must earn its nectar, which lies hidden far back in the long elf's cap botanists call the spur.

But notice the wiles of a fat bumblebee that has just alighted. Does she plunge headlong down the corridor leading to the hidden nectar? No. She forces a passage at the side, between two petals, and thus gains the spur's exterior. Quite involved, she holds still for a half a minute near the tip, then flies off.

For convenience's sake, the spur has just submitted to a minor adjustment: a hole in its side, thanks to which the bumblebee has short-circuited the ordinary access road, a flagrant case of nectar theft by breaking and entering. And other bees follow, freely exploiting this providential opening.

But these cheaters are blessed by extenuating circumstances. In its native land, Peru, the nasturtium is pollinated by hummingbirds, whose long tapering beaks can reach right down to the end of the spur. Here at home the bumblebee, whose tongue is much shorter, is forced into the role of ad hoc burglar.

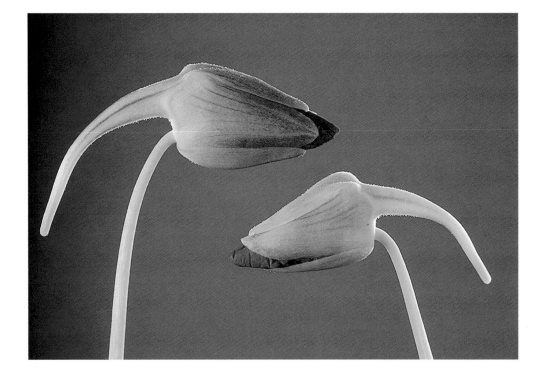

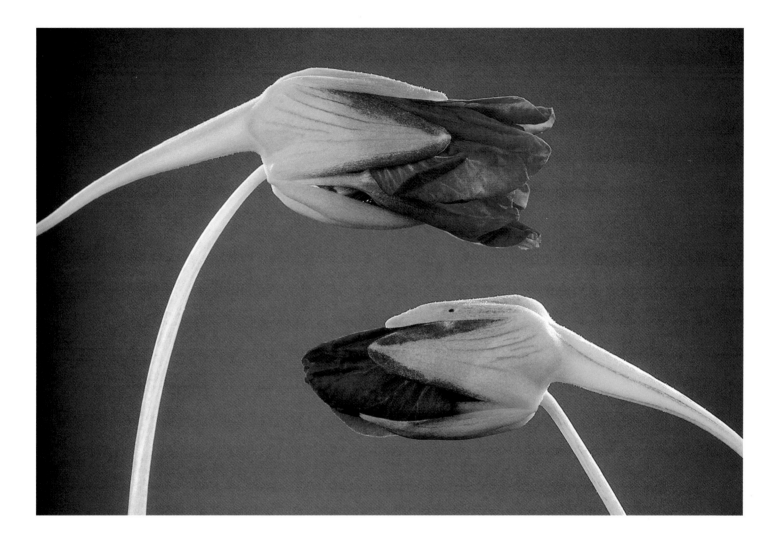

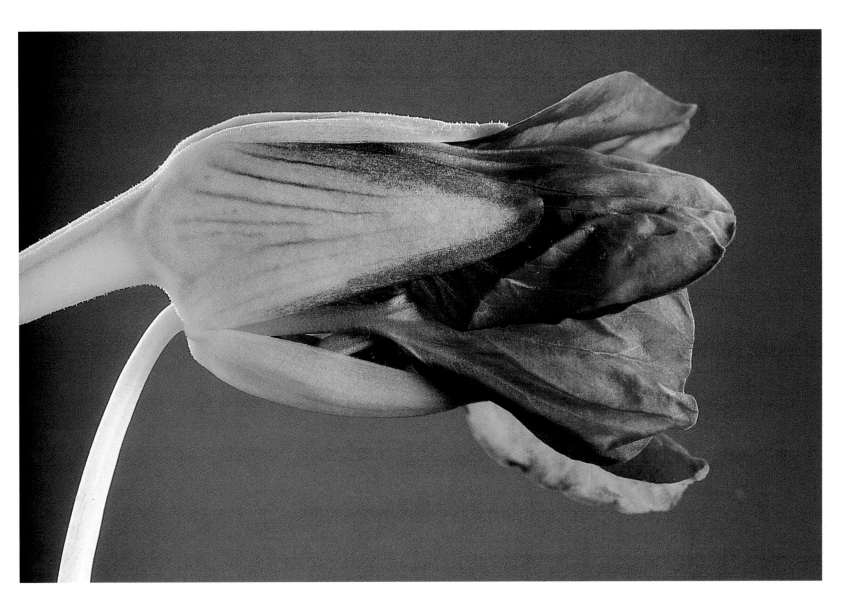

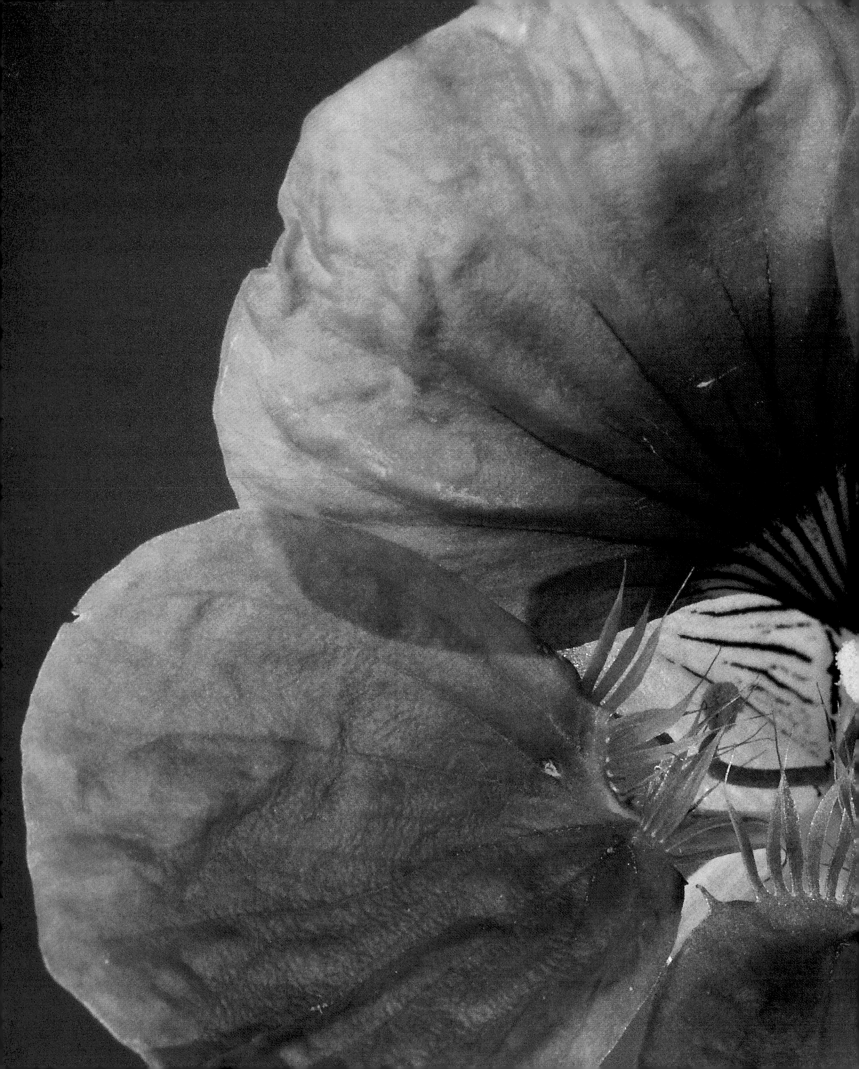

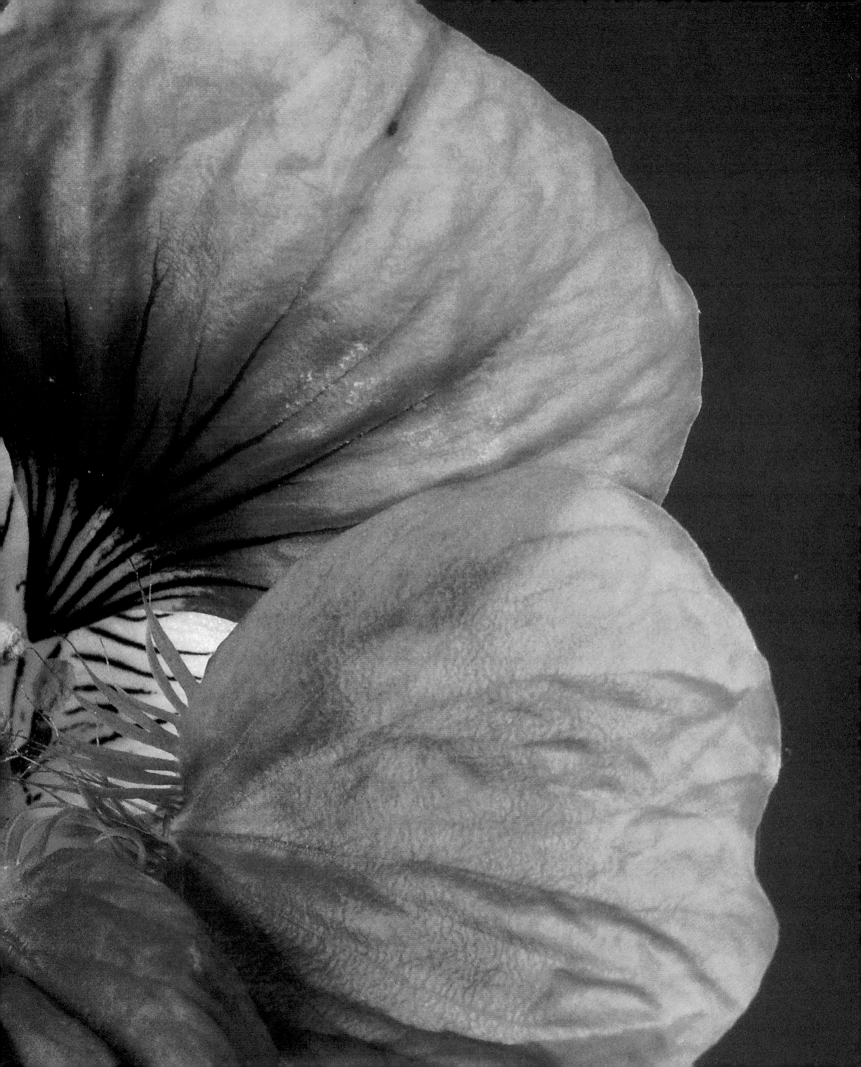

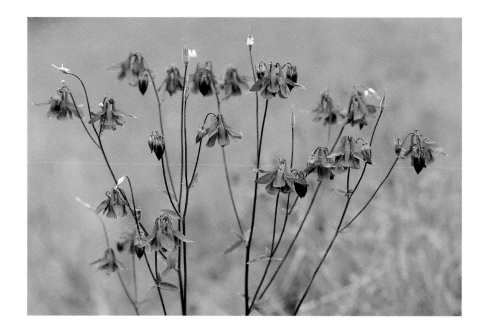

Columbine

\mathcal{C}ountry people have invented many names for this masterpiece of floral architecture. Our Lady's Gloves, Columbine, Cornet, and Five Fingers are some of the affectionate popular nicknames that its elegant shape has suggested.

When we spot its graceful silhouette emerging from the grass of shady meadows, we may well think that we are looking at a sophisticated horticultural specimen escaped from a neighboring garden. The flower's aristocratic bearing often serves it poorly, resulting in its head being lopped off by Sunday strollers and added to a bouquet of field flowers, a dubious honor that might at length lead to its extinction.

The flower begins at the end of a stem curved like the neck of a swan, a supple and undulant line that could be the design of an Art Nouveau stylist. The bud is suspended head-down, like a precious lantern of threaded glass. At first it is just a simple, streamlined sketch of a flower, almost colorless, but then it takes on the colors of blue tinged with pink and shows its insignia: five curved spurs in the shape of a crown.

Most flowers practice a precise division of labor between the calyx and the corolla. To the thick matte sepals goes the office of protector of the bud, to the petals that of brilliant attractive flags. Like the iris, the columbine knows no half measures. Each of its flower parts bears a perfectly solid color. Only the petals are grooved at the base with long arched spurs, which gives them a cornucopialike shape.

Those species of nectar gatherers equipped with a long proboscis manage to drink what her blossom contains, which is distilled right at the bottom of cornets more than two centimeters long. But so do the short-tongued bumblebees and honeybees, who get around the difficulties by puncturing the spurs' sides.

Fortunately, nature happily provides enough straightforward visitors to pollinate the flower, which then bears beautiful, velvety five-branched fruits in which rows of glossy seeds mature.

When I place a flower on my night table and sketch it faithfully,
it seems to me that, little by little, I comprehend the secret of creation.

<div align="right">Shiki</div>

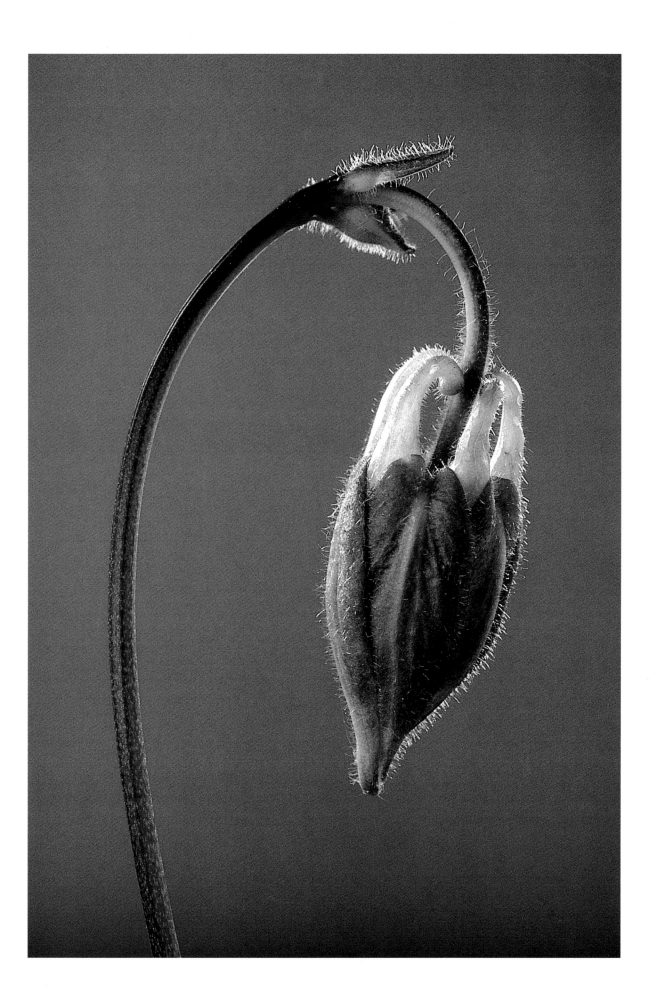

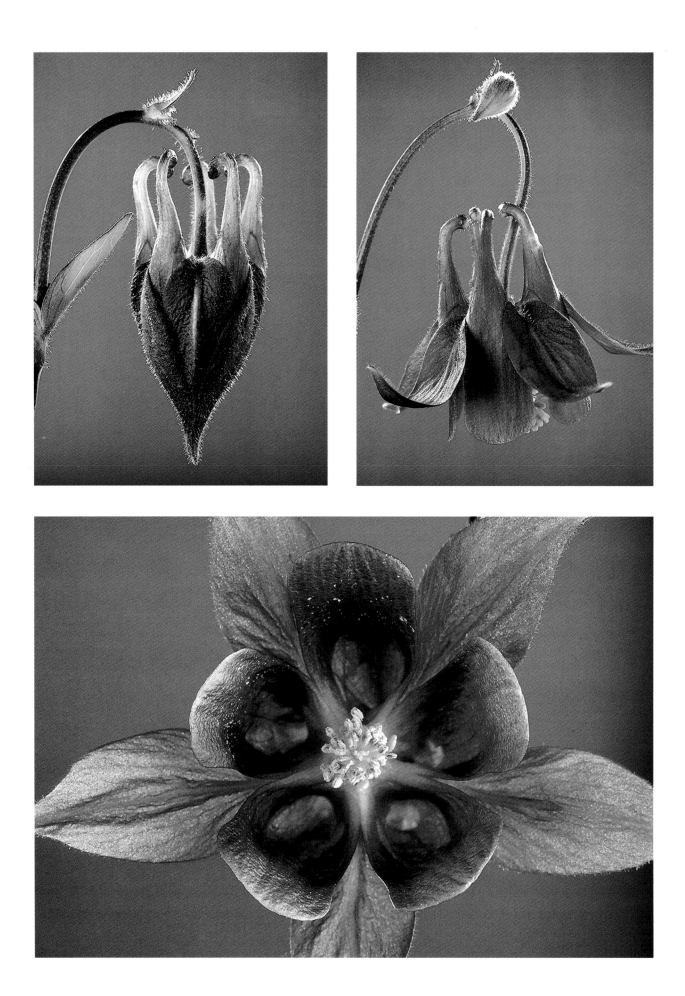

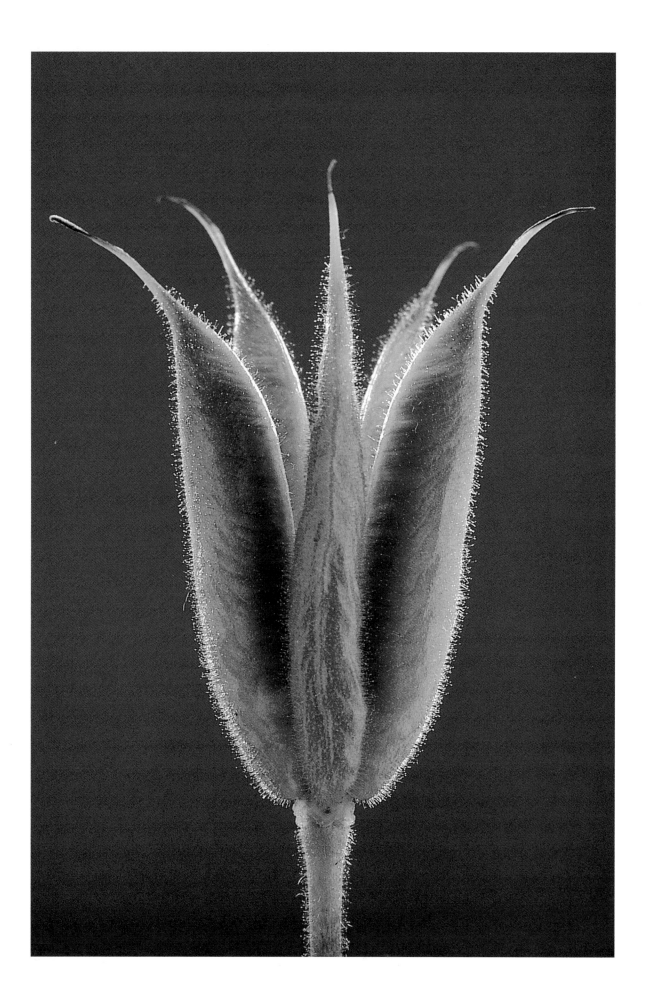

Teasel

The teasel raises its flowery heads to a height of almost six feet. The whole plant is built according to a very original architectural plan. Long leathery leaves unfurl at several points along the central axis, in fused opposed pairs, forming a succession of paired bowls, one pair above another up the stem. It looks like a monumental fountain with tiered basins, a prince's folly or an artisan's masterpiece. Rainwater running over the rigid leaves collects in these basins as if they were gutters.

For a long time it was thought that, thanks to this system of defensive moats, the plant protected itself against insects and mollusks by blocking their ascent of the stem. And in fact, numerous drowned creatures demonstrate the trap's effectiveness. But today it is thought that the teasel derives a more substantial profit from its victims. The bacteria that cause them to decompose transform the water into a rich medium from which the leaves can draw nutrients through their epidermis. Perhaps then, behind the teasel's sedate ornamental facade lurk the tendencies of a carnivorous plant.

Unlike thistles, which concentrate their flowers in a tuft at the top of the plant's head, teasels cover the whole of the head's surface with their corollas, which are enshrined within rows of thorny bracts. This purposeful decentralization allows them to fit more than a thousand flowers on the capitule.

But this multitude does not blossom all at once. A first wave of blossoming seizes a large ring of buds around the capitule's waist. By evening these first blooming corollas fall to the ground. Then, day after day, the lilac-pink blaze spreads in two directions through the neighboring areas, progressing by ever-diverging rings toward the ends of the plant's head.

After a week, all the flowers have bloomed. Butterflies and bumblebees have delighted in these masses of continuously renewed, nectar-rich flowers. As soon as the blossoms disappear the plant begins to dry upward from the foot. The capitule becomes now an austere pincushion, from which, in autumn, seeds that goldfinches will be pleased to hoard will fall.

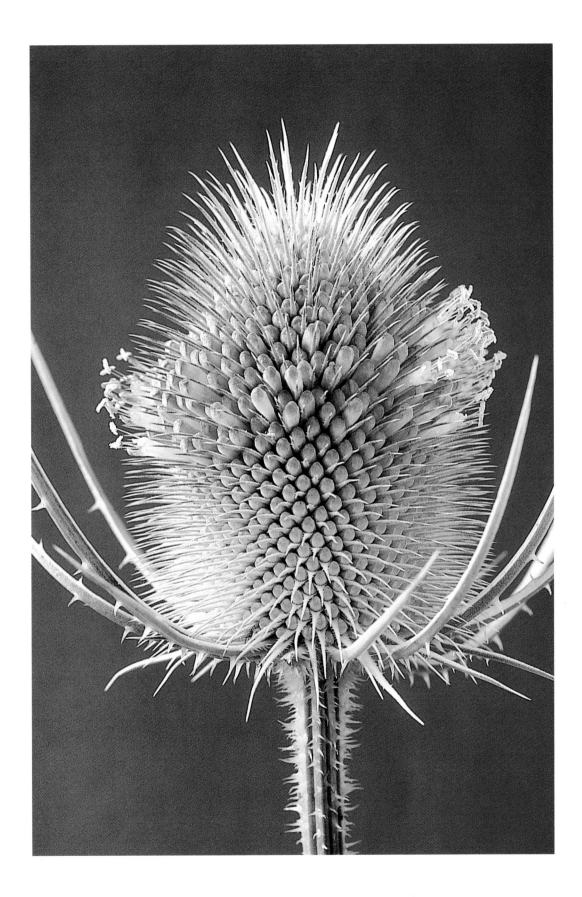

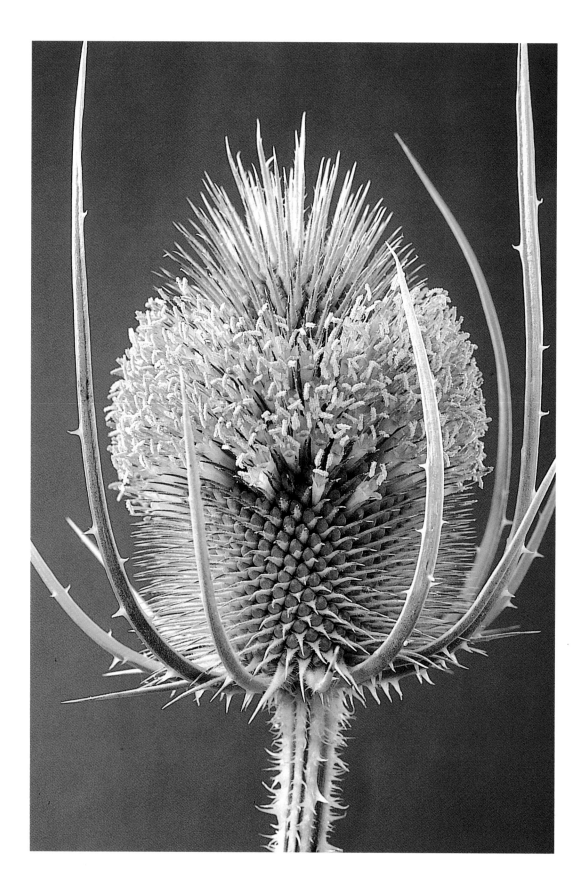

If it were only to the eye that flowers were beautiful they would still charm;
but sometimes their scent, like a felicitous term of existence, like a sudden call,
leads toward a return to a more intimate life.

<div align="right">SENANCOUR</div>

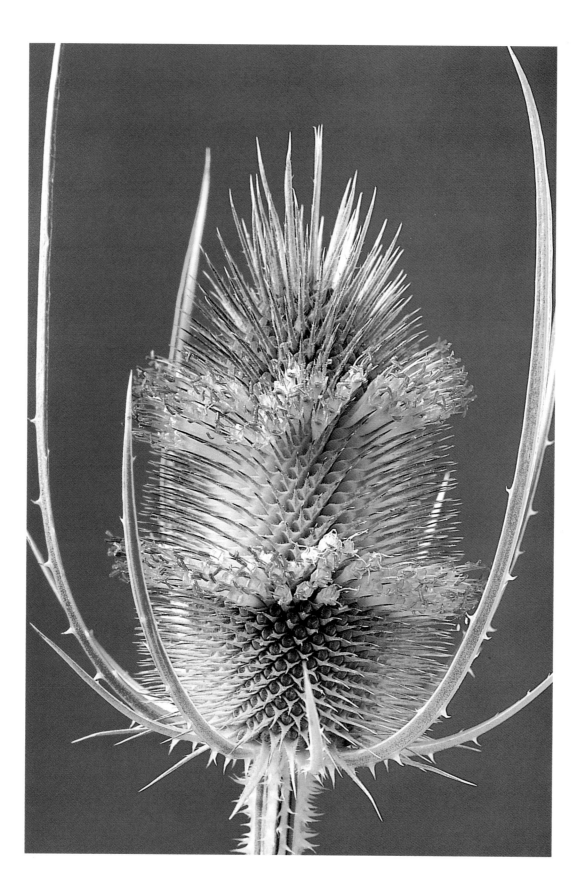

If it were only to the eye that flowers were beautiful they would still charm;
but sometimes their scent, like a felicitous term of existence, like a sudden call,
leads toward a return to a more intimate life.

SENANCOUR

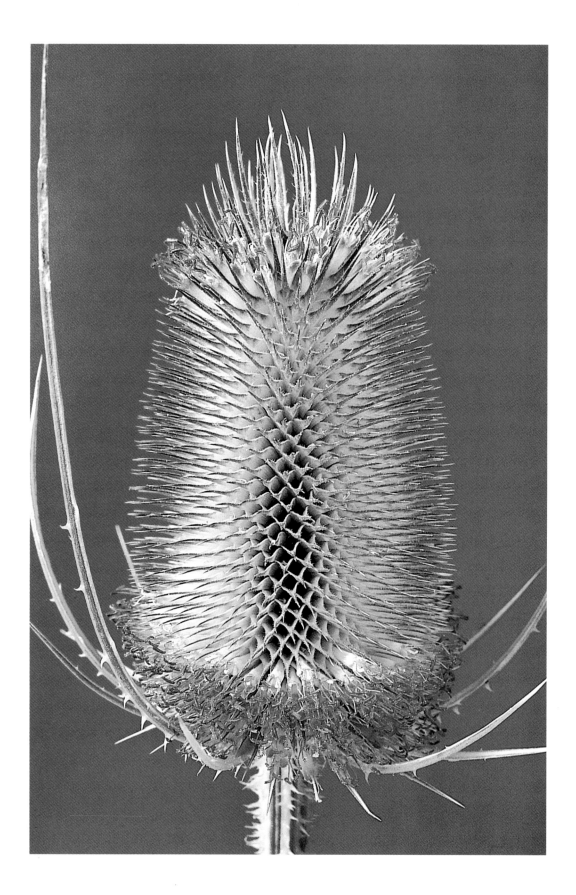

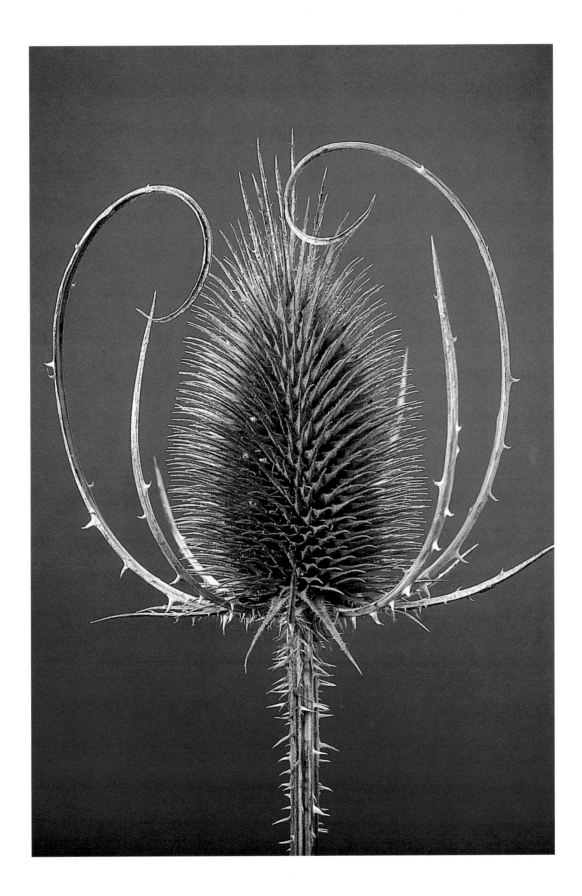

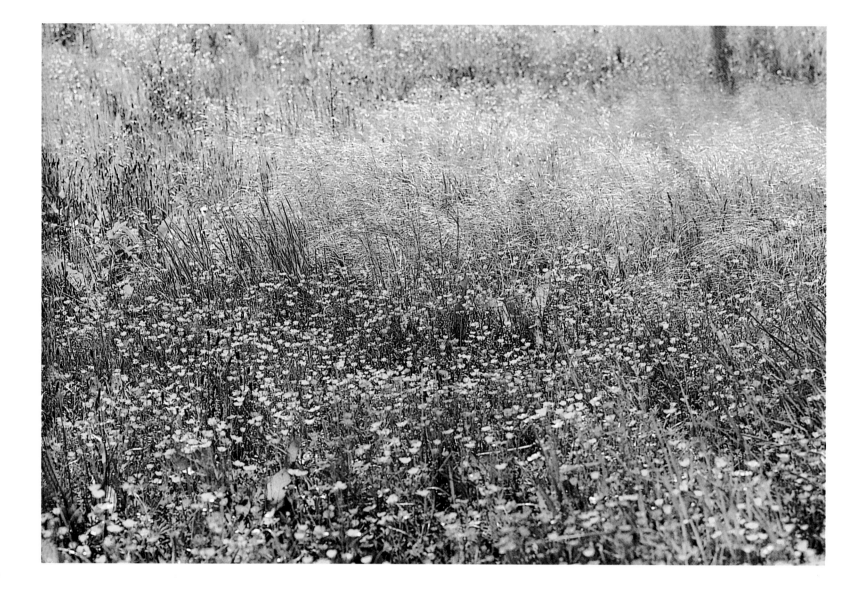

Buttercup

The name buttercup makes little sense when the *Ranunculus* (the scientific name for buttercup) is in the bud, which offers only a pale-green livery. Five tightly joined sepals covered with fine down enclose the nascent corolla within a rampart that serves as an obstacle to outside attacks while, within the confined space of its protection, the petals develop. As they slide imperceptibly one over the other, their movement is facilitated by the natural oil on their surfaces, which serves as lubricant.

When the sepals at last open, such a simple flower emerges that it could have been drawn by a child. But what brilliance! The petals' upper faces are covered with a shiny, waxy—or perhaps one should say "buttery"—glaze. Thanks to these mirrorlike surfaces, the flower appropriates part of the sun's dazzle. Flies and other short-tongued insects dash toward this beacon where they find an easily reached nectar. Each petal bears a small tongue at its base, above which the elixir may be found.

The buttercup is built to assure the spread of its pollen. Its structure forces insects to follow a prescribed route in order to arrive at the nectar, so that they are inevitably covered by pollen along the way. In fact, when a nectar gatherer lands on the corolla, it must clear a path through a forest of about fifty stamens, with the result that a veritable yellow rain pours down on the visitor. This is a bizarre sight indeed. However, to a botanist this great abundance is a primitive trait; more fully evolved flowers know how to make do with only a few stamens.

The shedding of the blossom makes way for a fruit bristling with thirty small flat compartments, each containing a single seed.

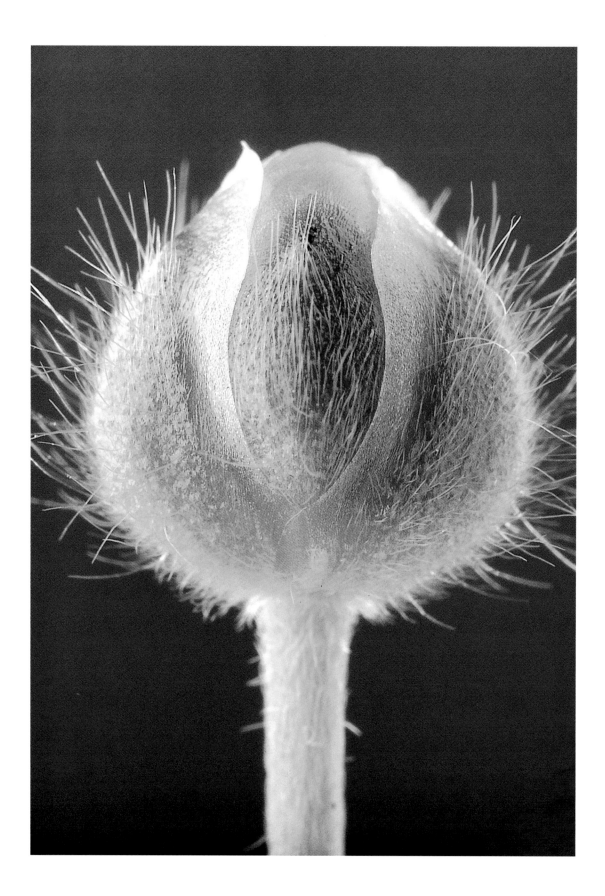

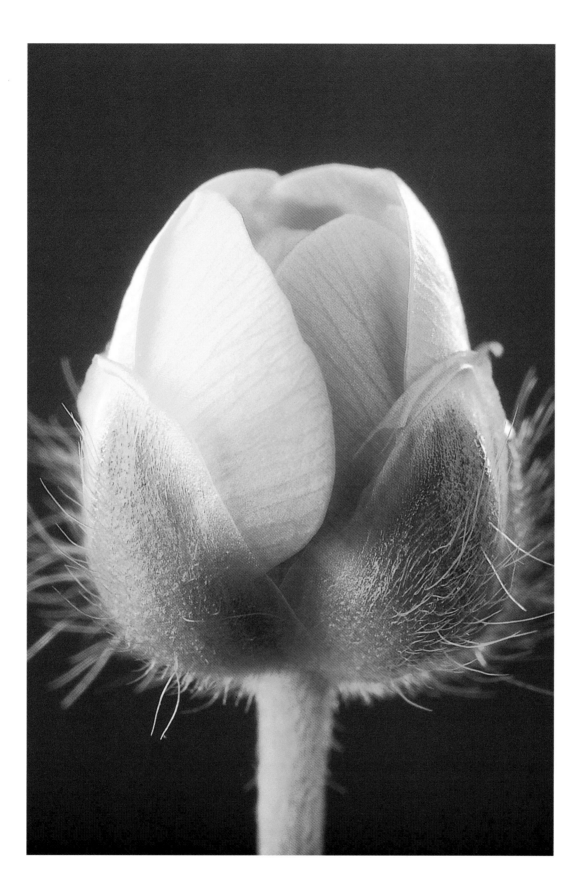

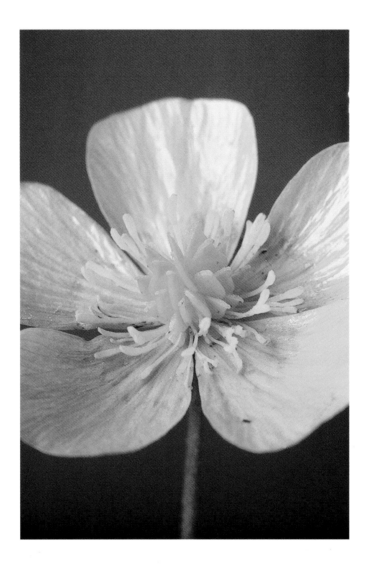

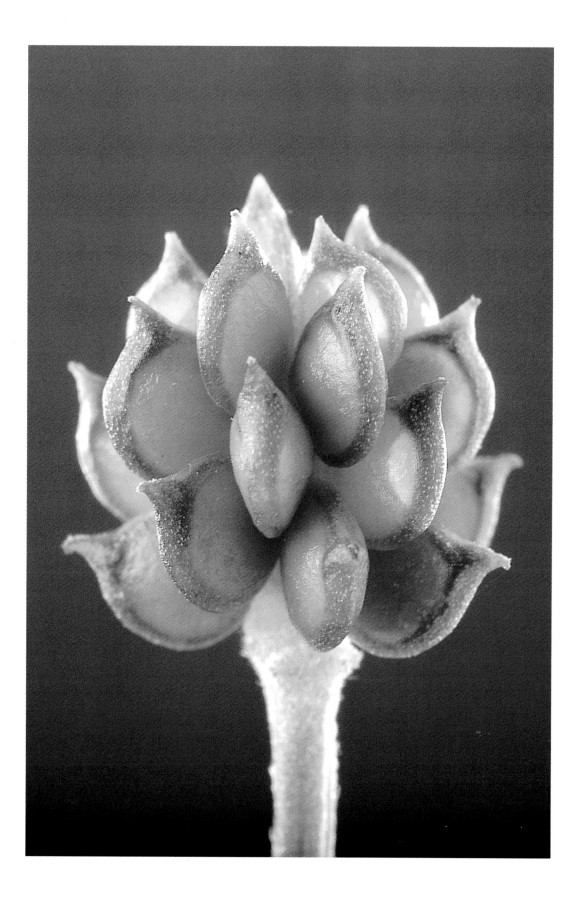

Scabacious

When they practice the art of the bouquet, flowering plants show great virtuosity. Umbelliferae present large open compositions, thistles upright sheaves, and teasels pyramids of close-set flowers.

In this overabundance of inventiveness, the little scabacious's creativity cuts an innocent figure. This quite simple field dweller presents little round nosegays rather like tiny bridal bouquets, held half proudly, half embarrassedly, by maids of honor and groomsmen. The traditional wreath of leaves of the bridal bouquet even finds its counterpart in the ornamental appearance of the green bracts embracing the flower's head.

Before becoming a festive bouquet, the scabacious is so compact that it is entirely covered by its encircling bracts. When it is time to bloom, these spread out laterally, from the internal pressure of about fifty buds; those at the periphery of the cluster are the first to turn pink. The color quickly spreads over the rest of the head, which swells gradually day by day.

Suddenly one morning it is bordered by large pink festoons. These are the flowers at the periphery, which have just opened. Henceforth, the flowers continue to open, from the outside inward, little by little. It is a subtle cameo, pink-, lilac-, and salmon-colored. The larger outer corollas form a gathered flounce surrounding the compact gathering of small central flowers. All together they release a heavy, honeyed scent that attracts the bees.

Pollinated, the scabacious suddenly abandons its colorful decoration. The corollas fall, making room for a perfect hemisphere, where a more severe geometry reigns. Each star-shaped crest springing from the former calyx crowns the upper ridge of a seed. When the seeds detach themselves from the capitule, these slender crests are powerless to help break their fall. Not every plant masters the art of riding the wind.

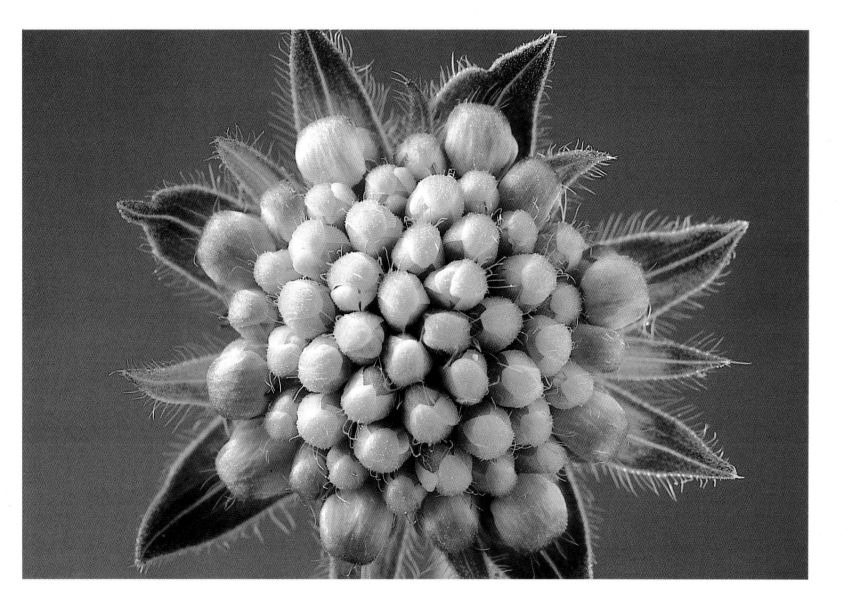

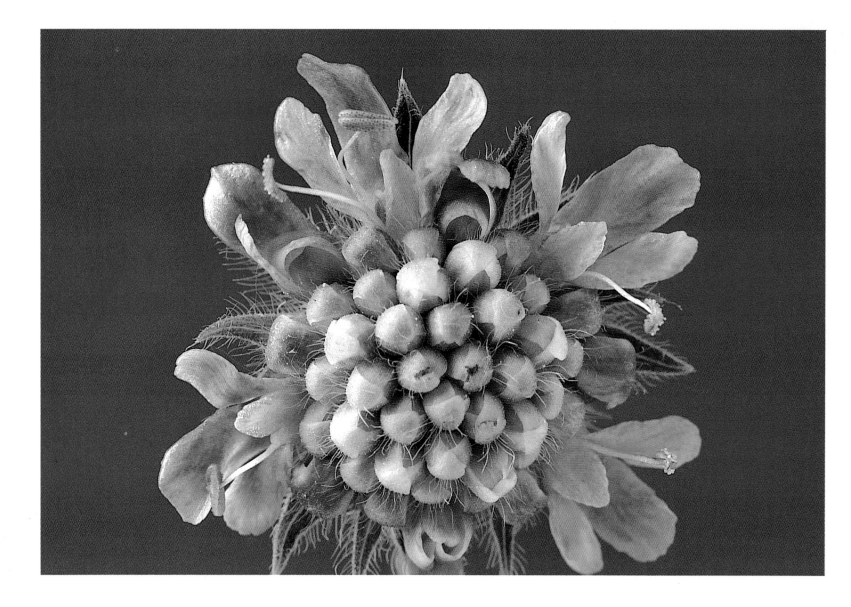

To the man who says
kids bore him
flowers too are as nothing.

BASHŌ

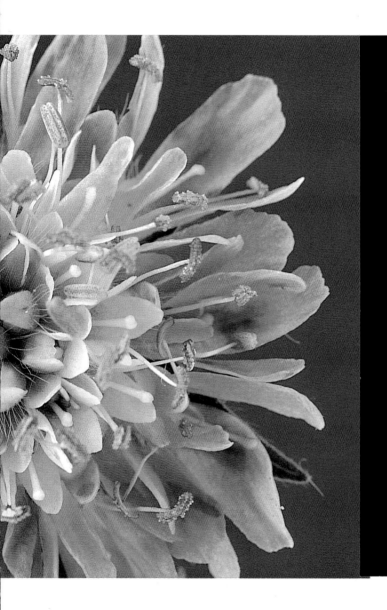

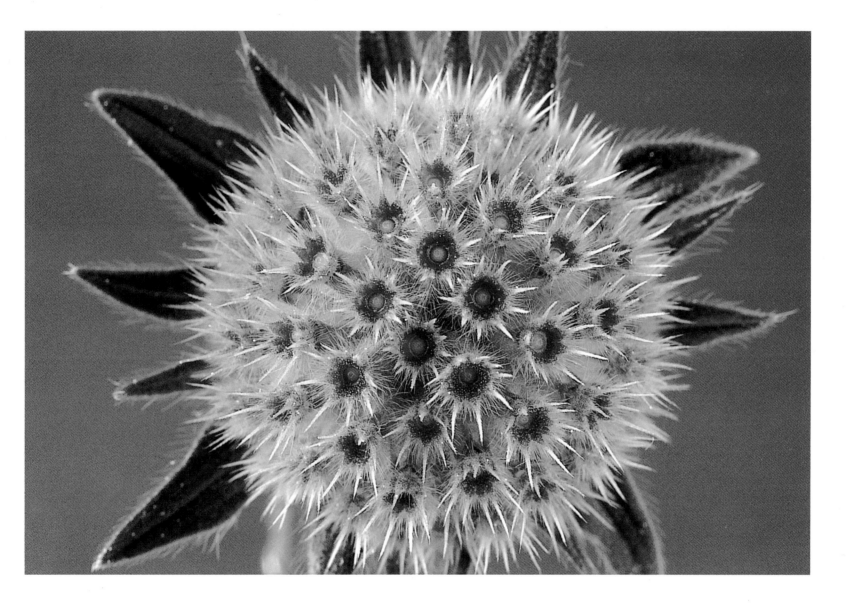

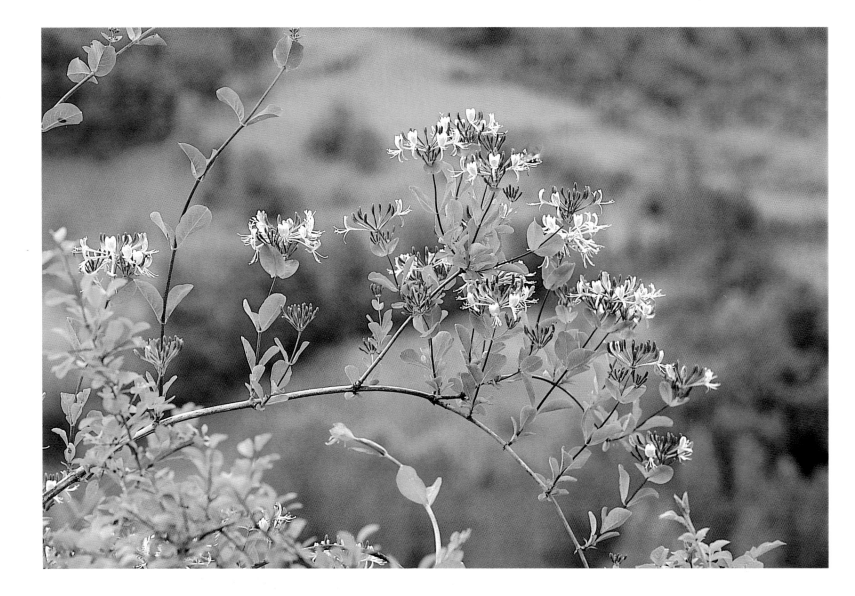

Honeysuckle

Underbrush: such is the botanist's verdict when it comes to define the honeysuckle's vegetal type. However, while marveling at the imperial carriage of the plant, I can't help thinking that it should be spared this humble designation, which smacks of some obscure subaltern rank in the grand army of plants.

The honeysuckle is worthy of a more exalted rank in the floral order of merit. Even in its bud phase it exhibits an accomplished sculptural sense. At the extremities of the branches, above its two last leaves, which are joined at their bases, to form an oval bowl, a curious three-part structure arises.

In the center, at the end of the stalk's longest extension, is the principal head, with the most numerous and vigorous buds. Flanking this princely eminence are two attendants, whose development suffers under its hegemony. We shall occupy ourselves only with the fate of this dominating cluster.

The central head numbers a score of floral buds, which are plump and extended like fingers. First greenish, then turning a pale pink, they become thin and take on an elegant double-curved line. Their opening is sudden and explosive. The seams that hold shut the tip of the corolla abruptly burst open, splitting the tube into two lips that curl back upon themselves, freeing the stamens and pistil. The lower flowers open in turn, one after the other, as candles in a candelabrum are successfully lit.

Children, to whom the least of nature's offerings is a delight, well appreciate the sweet nectar that they suck in by breaking the tube off at the flower's base.

But the most important imbibers attracted by the honeysuckle's elixir visit only at twilight. These are the huge Sphinx moths. They are equipped with a custom-made tool: a long tapered tongue that they unroll into the bottom of the corolla, hovering over it all the while like hummingbirds.

As the corollas fall, they reveal an interior ornamented with scarlet concavities, waxed like candied fruits.

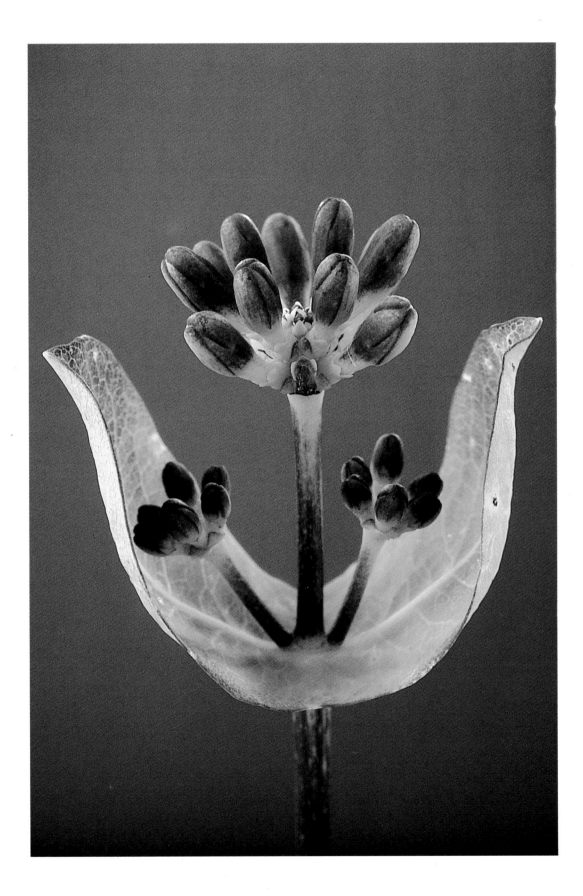

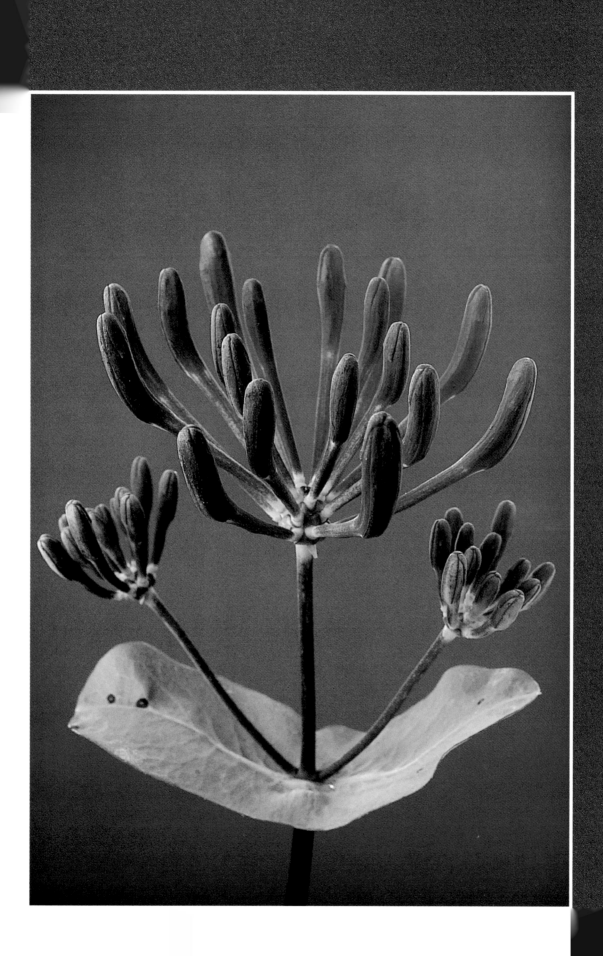

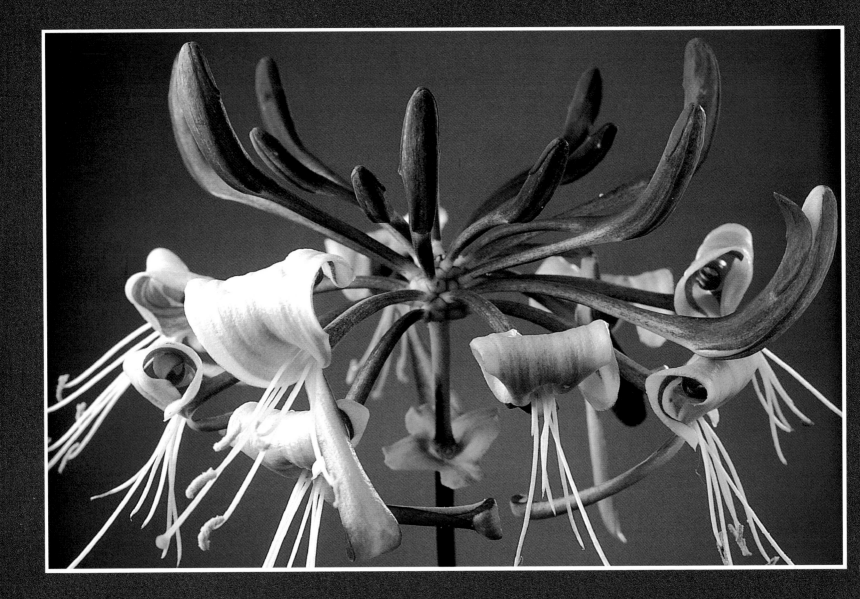

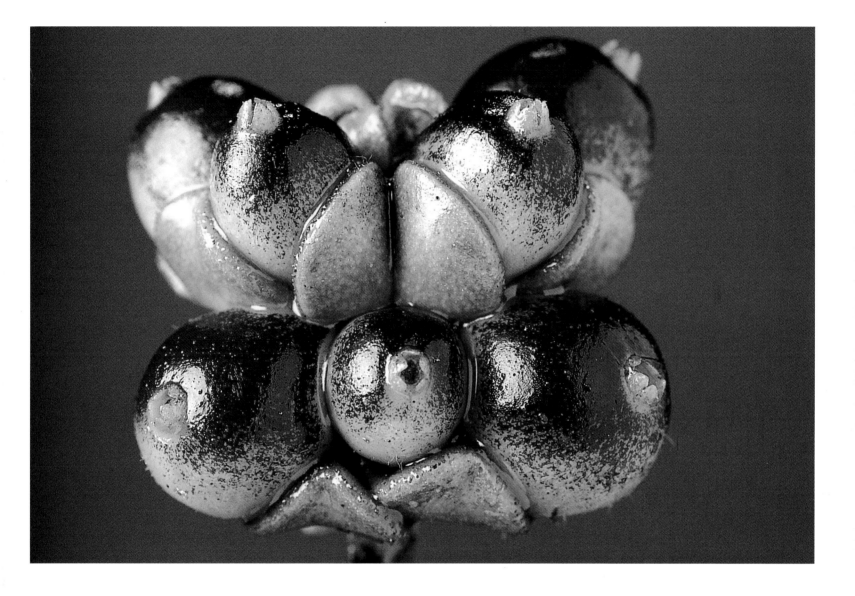

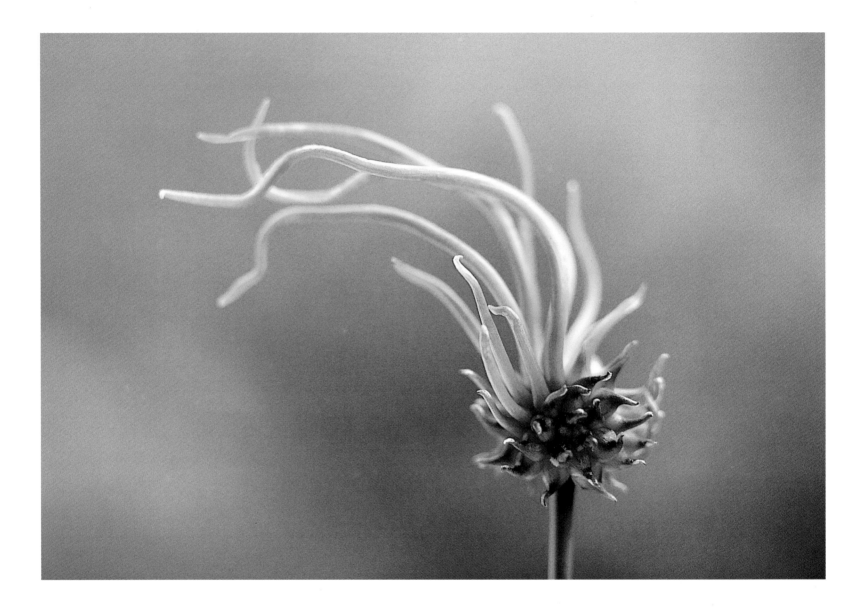

Round Head Garlic

At its moment of bloom the garlic is seized by a sudden intoxication, a delusion of grandeur that makes it lift its stalk straight and round as a reed high above its skimpy leaves. Just at the top of this shaft there is a light swelling reminiscent of the bulbous domes of Russian churches. This object is tightly closed, mysterious. Little by little it takes on girth. Its inner walls become as translucent as tissue paper. It seems shaped, warped, and dented by obscure internal pressures.

A new burst of enthusiasm and the membrane bursts longitudinally. What does this vegetal lying-in bring forth? A perfectly round head, knobbed like a blackberry, comprising a hundred tiny and still-green floral buds.

As soon as it emerges from its cocoon, this young crowd, which the garlic has enveloped with a protective bract during its first moments, rapidly grows in volume. If you pass your finger over its seemingly compact head you are surprised to see the buds shy away from the pressure. Each one perches at the end of a short stalk diverging slightly from that which holds its neighbor.

The garlic's flowering is an umbel whose architecture remains hidden. Far from the light and ethereal style of the hartwort, the garlic's umbel is compact, dense, and hard.

Blooming proceeds from the summit to the base in a rush of contagious scarlet that soon takes over the whole top. In July, when sources of nectar are rare in the dry regions where garlic tends to grow, these generous bouquets of miniature flowers pointing toward every horizon attract hosts of butterflies.

In summer heat the corollas give way to small dry triangular capsules, each containing a few black seeds. But it is underground, near its bulb, that the plant provides for its future. Little round growths distorting the stalk are also young bulbs capable of engendering a new foot. A rudimentary mode of multiplication, true, but a good reserve if the seeds should fail.

I am about to proclaim my audacity by asserting the significance
we must accord to grass, silent, humble, the most obscure.

PLINY THE ELDER

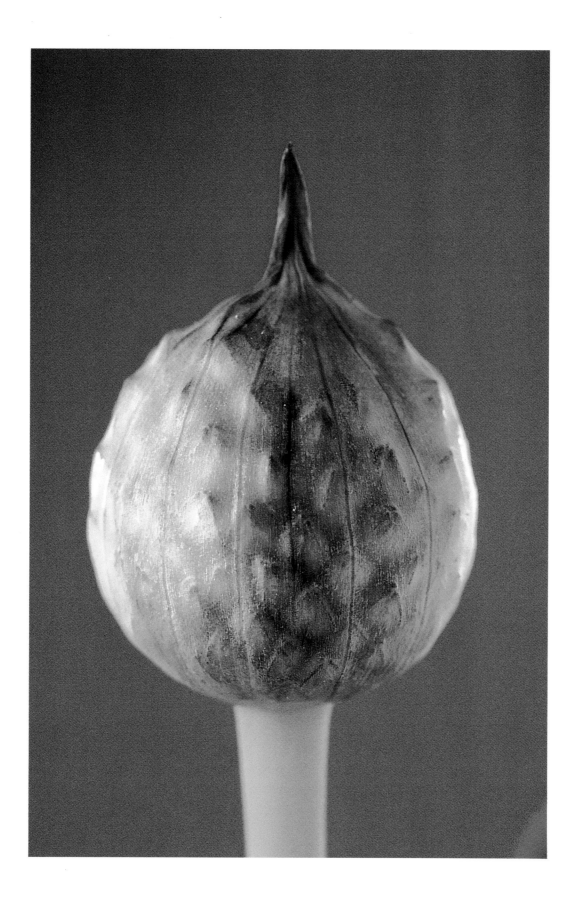

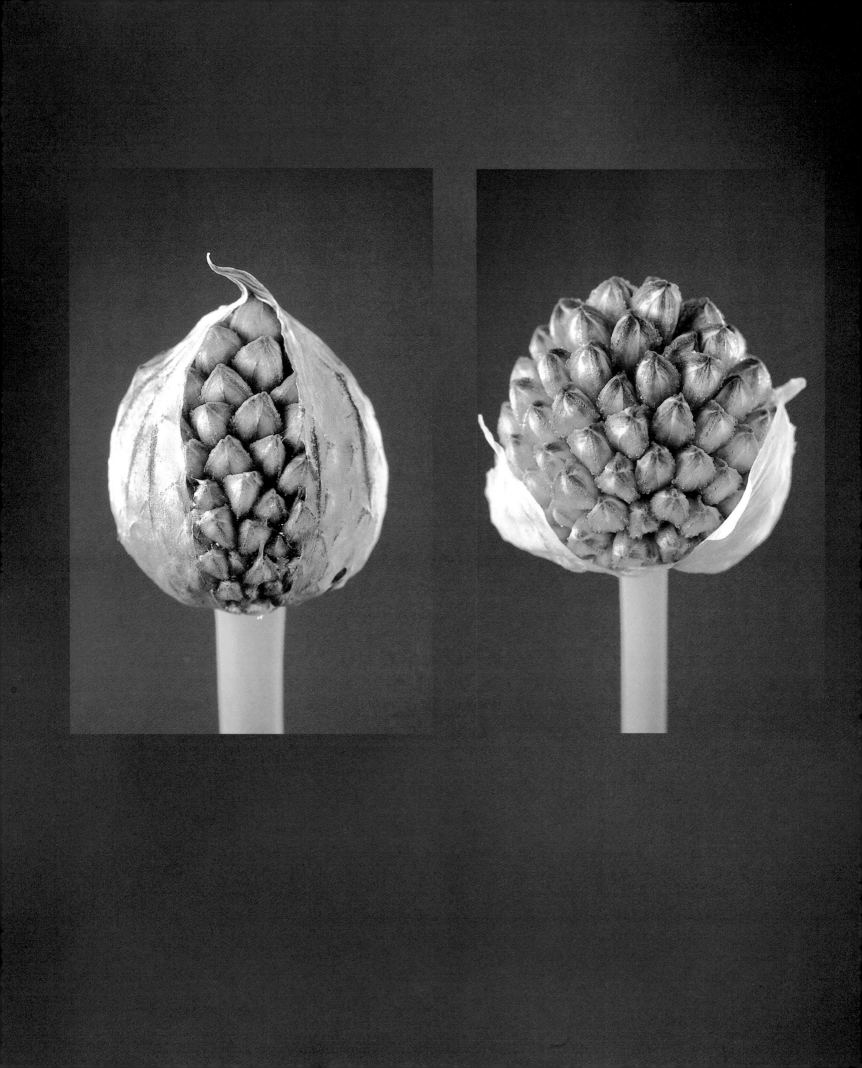

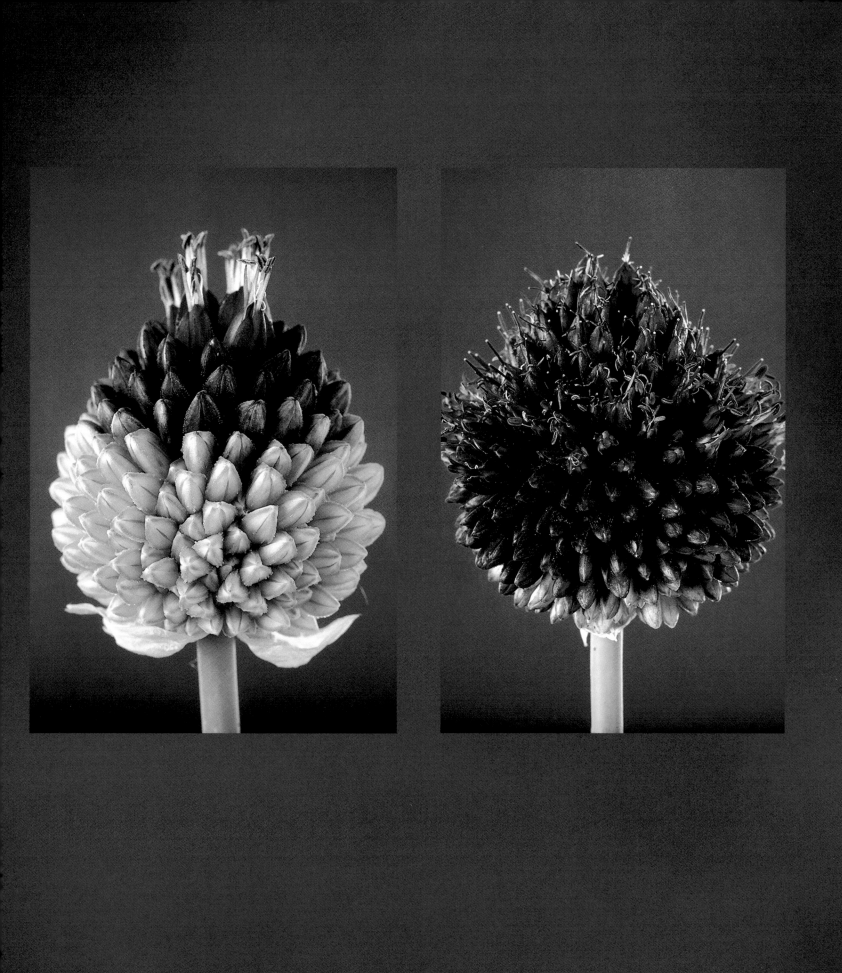

Sage

What area of knowledge has not succumbed to the temptation to protect itself behind an occult language? Although botany hasn't been immune to this perverseness, it has also sometimes been known to create richly imagistic terms, such as "labiates," denoting the family of the sage: a family of thick-lipped flowers, flowers with great open mouths that invite nectar gatherers to descend their gullets.

At first the sage's corolla is only a kind of uncut gem, dark amethyst in color and set in a cornet of sepals. Then the muzzle of the flower pokes out of the calyx, and its sealed lips open in a fixed gaping yawn.

The sage belongs to the aristocracy of flowers. Its architecture expresses the height of floral genius. The lower part of the corolla, once broadened, serves as a landing stage for visiting insects. When, in order to harvest the nectar, they dip their heads deep into the throat, they must push headlong through a barrier and so cause two long stamens to oscillate with the contact of their velvety backs, which are then covered with pollen. Honeybees and bumblebees, the intellectual elite of nectar gatherers, easily learn how to follow this subtle mechanism's operating instructions.

The sage's flowers thus ingeniously transformed into automatic pollen dispensers, the plant places them at staggered intervals up its stalk in superimposed rings. But this edifice sometimes attracts visitors who are no help to the task of pollination. These include both a tiny fly of the *Empis* genus, which manages to slide its fine, rigid proboscis into the center of the corolla without triggering the lowering of the stamens, and the Moro-Sphinx butterfly, which conscientiously visits all the flowers of a cluster, hovering over them like a hummingbird. This butterfly insinuates its long threadlike proboscis as far as the nectar glands by slipping it under the barrier. In both cases the flower is duped into giving up its nectar without having its pollen transported in return.

But these bad sportsmen are the exception; the sage certainly welcomes enough bona fide visitors so that, at the bottom of each calyx, it forms four little black and lustrous seeds to perpetuate its mastery of the science of mechanics.

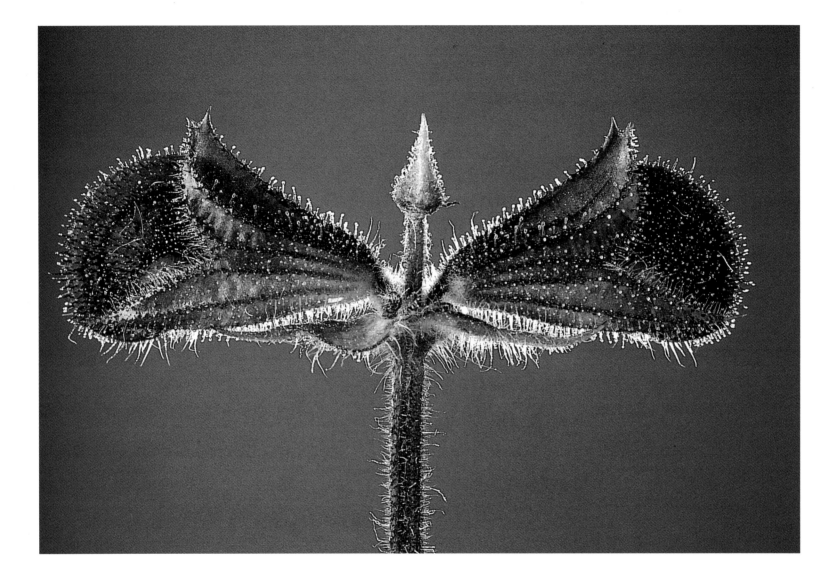

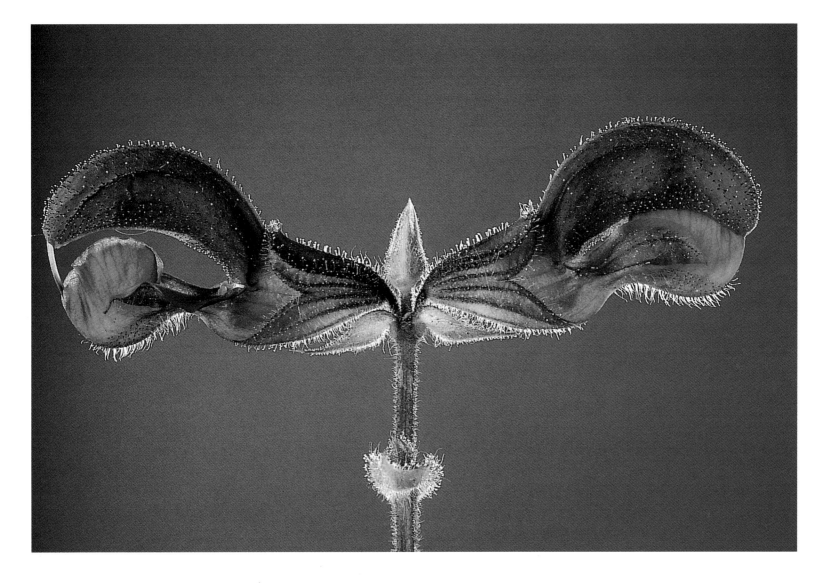

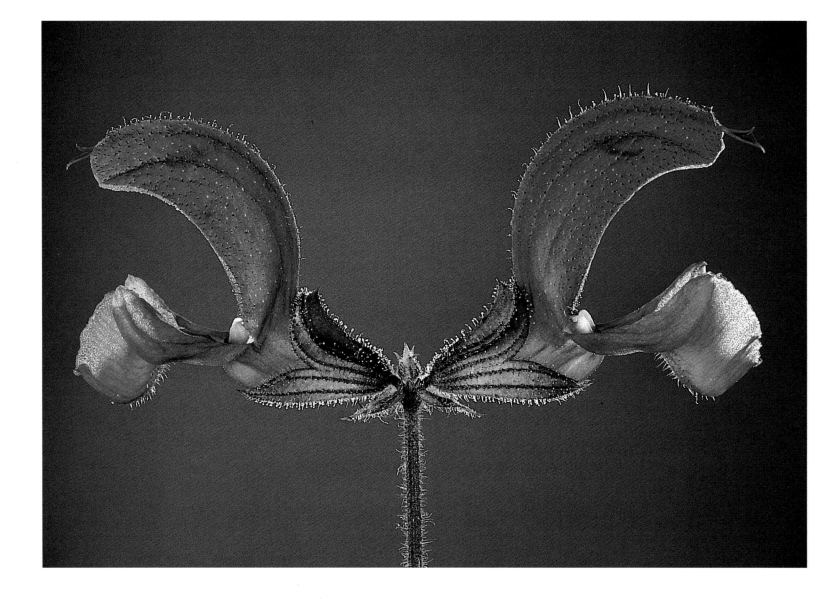

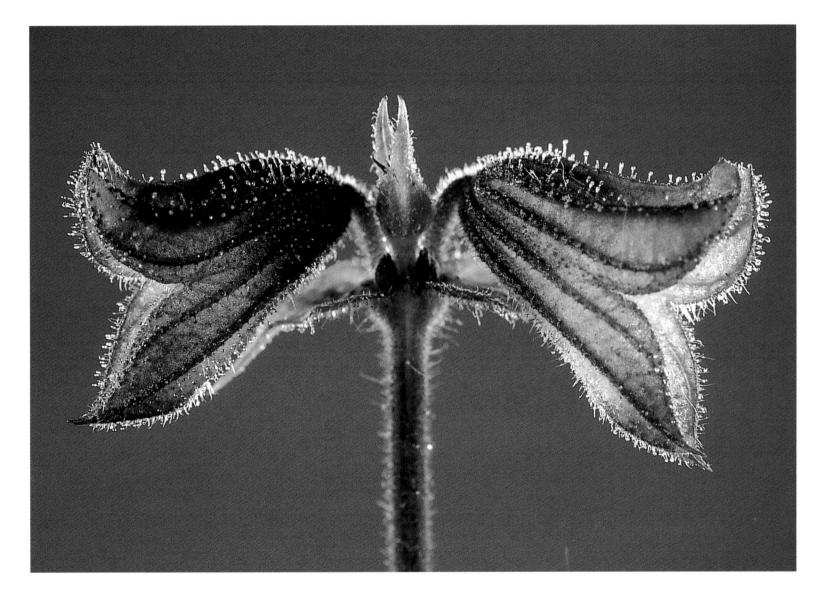

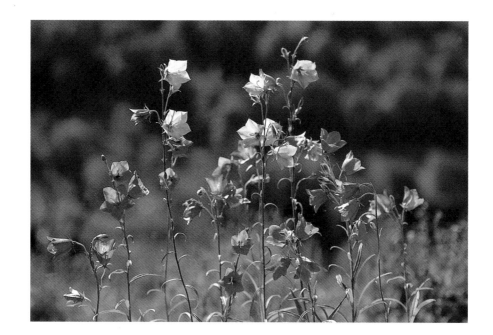

Bellflower

In constructing their floral palaces plants do not follow the logic of architects. Instead, they are experts at the arts of folding (and of unfolding), stacking, spanning—at everything, in short, that enables them to store immense surfaces in a little room. For before becoming flowers they must be buds, a concentrated phase that allows delicate flower parts to develop in a protected space.

Thus the bellflower's small bell (the meaning of the Latin *Campanula*) is at first only a miniature ovoid with fluted inner walls resting on a plinth of star-shaped sepals. This enclosed pale-violet body partly opens at its top, allowing a lacy border to appear. Then, by unfolding its undulating, accordionlike surface, the corolla takes on its definitive volume: the egg is metamorphosed into a bell.

Like the fireweed, foxglove, or geranium, the bellflower avoids self-pollination by having its male and female organs maturate at different times. First come the stamens, which dust visitors with pollen, while the pistil is still only a short, incomplete column. Then the empty stamens shrivel into the corolla's depths, and the pistil raises its three threadlike stigmas, ready to receive pollen which nectar gatherers will have collected from neighboring clumps of younger flowers. First male, then female, the bellflower practices its sex change in order to avoid impregnating itself.

Not only does the bellflower provide nectar gatherers with nectar to drink, it extends its solicitude to the point of providing them with a shelter for the night or against the rain. Moreover, in this comfortable floral dormitory, insects enjoy a microclimate measurably warmer than the temperature outside.

This little bell's blue period lasts more than ten days, after which the corolla pales, retains for a little while a faint, exhausted last gasp of hue bordering on violet, and then contracts its sepals into what looks like a shriveled torch.

In the dry fruit three round orifices open which—when the wind takes a mind to shake this rattle—allow a hailstorm of tiny brown seeds to escape.

In the organic world, the more obscure and feeble the reflection,
so much the more does grace extend, radiating and sovereign.

<div align="right">HEINRICH VON KLEIST</div>

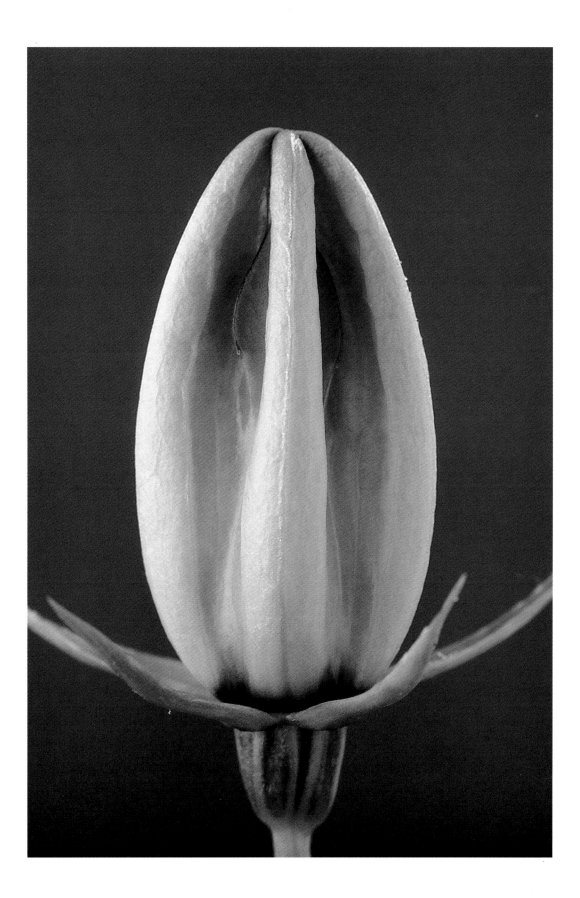

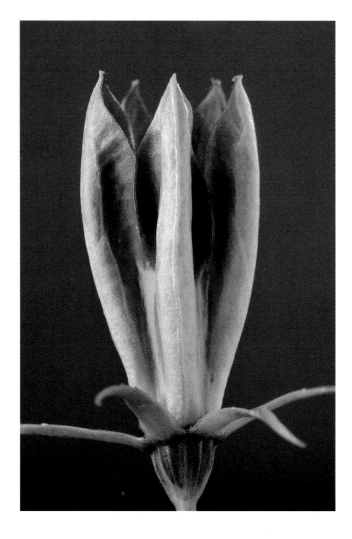 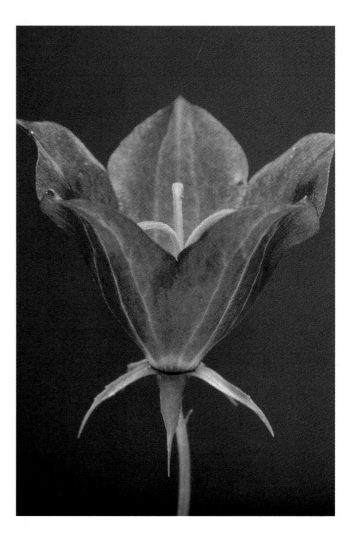

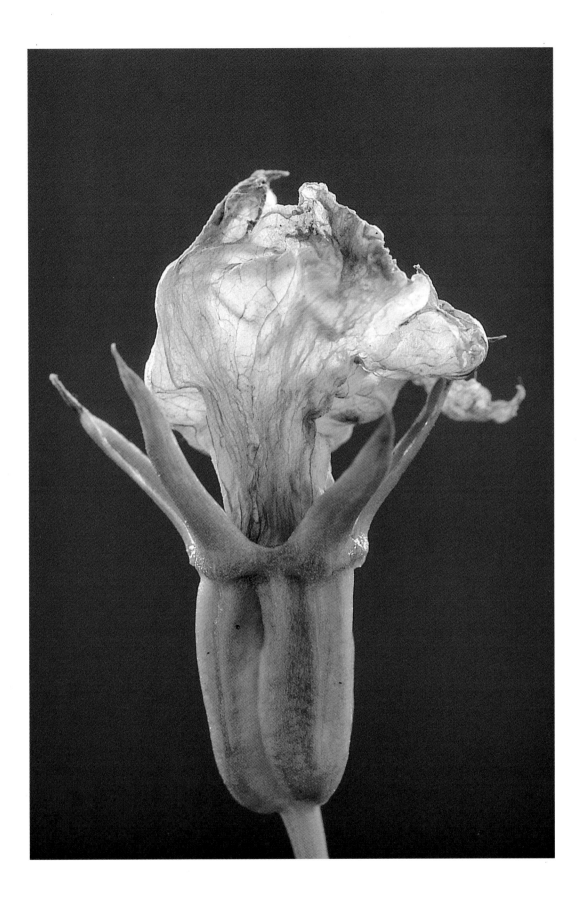

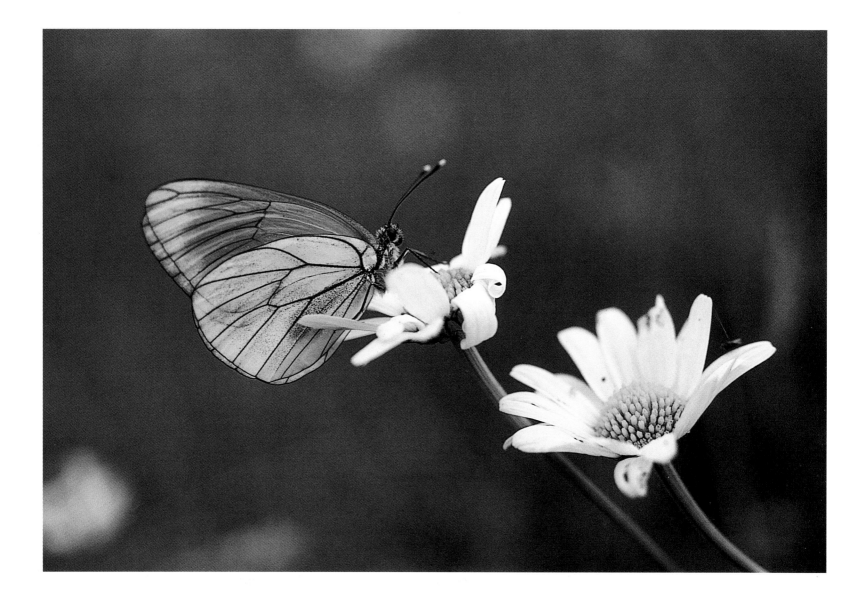

Daisy

We end these floral biographies with a queen's portrait. The daisy's common name in some languages derives from the Latin word for "pearl," and formerly, it was called *Chrysanthemum*, or "flower of gold." For once the praises of scientific and popular language are in accord.

The golden-domed daisy crowns the vast family of Compositae—a family that, as has been pointed out earlier, shares with the orchids the most exalted rank in the botanical hierarchy. At the heart of this prolific dynasty, which numbers thirteen thousand different species, the genus *Radiees* is considered by botanists the most evolved. And it is here that we find the daisy.

It spends its childhood enclosed by a triple wall of green leaflets with black linings. The flower bud is at first a slightly flattened sphere, but soon the top shows a snowy cap. The thin white petals within the bud press toward the center and protrude like pikes jutting out from the green enclosure. Then they straighten out again, crisscross in battle formation, overlap each other and, pressing their tips together, form a cone. Finally, petals and bracts open like eyelids and lashes, unveiling a fascinating golden eye.

Consider the heart of a daisy for a moment under the glass, and you will be captivated by dizzying spirals. For as these two to three hundred tiny flowers press against each other they form a pavement determined by an erudite geometry comprising two spiral sprays crisscrossing outward from the center. The daisy photographed here shows thirteen spirals unwinding toward the right and twenty-one toward the left.

Thus what we call the daisy's "flower" is actually a company of flowers—a hierarchically organized society with a strict division of labor. At the center, pressing their tiny, yellow, tubular, and hermaphroditic flowerlets together, are the corollas—the most populous caste. Surrounding them are ligules, exclusively female and in general sterile. As the corollas buckle outward in long immaculate blades, the ligules assume the role of petals.

As a group corollas and ligules execute a gold and white choreography that attracts hosts of nectar gatherers. Once pollinated and its nectar dried up, the daisy's deserted capitule resembles a fallen king trailing his finery. The unprepossessing blackish seeds will give birth to new flowers, beaming like suns.

Concerning flowers' dreams
I will query the butterflies
even though they can't speak.

REIKAN

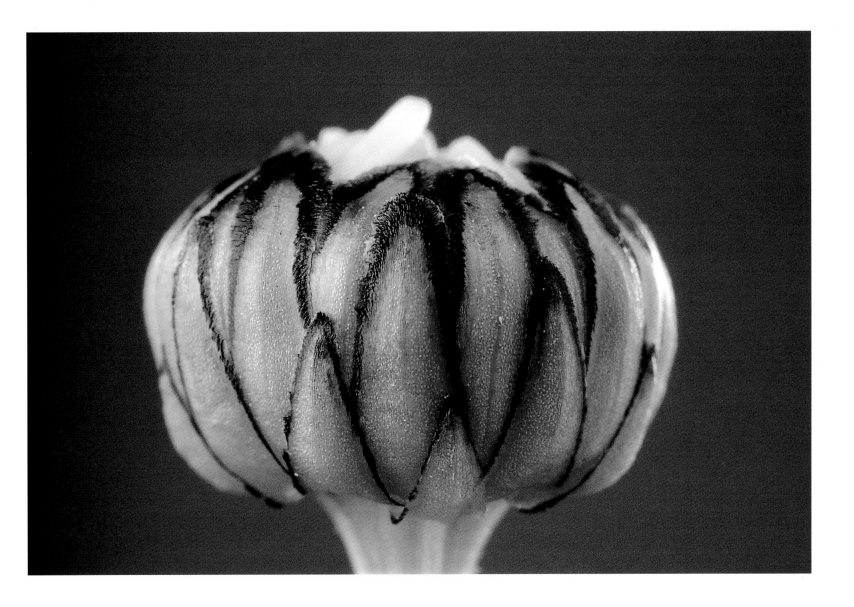

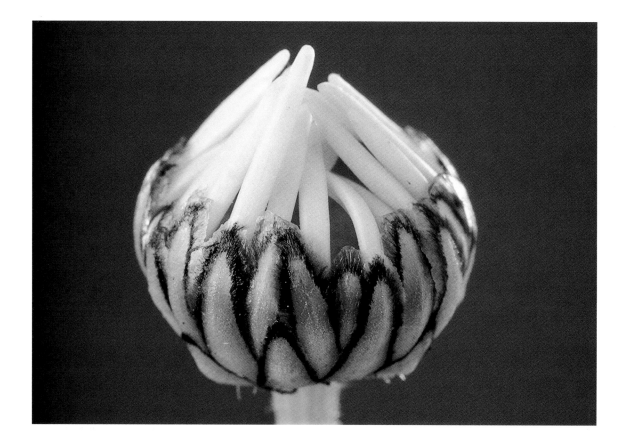

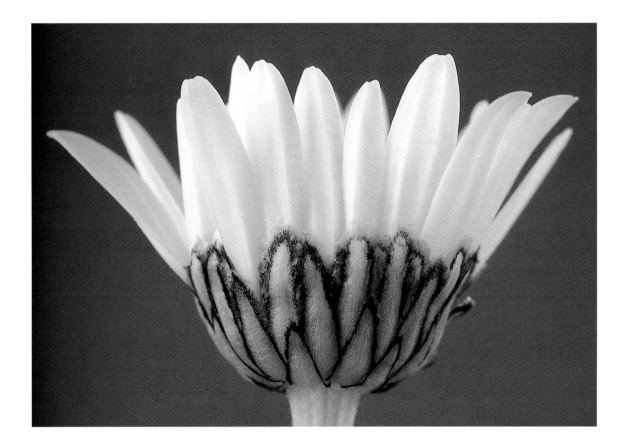

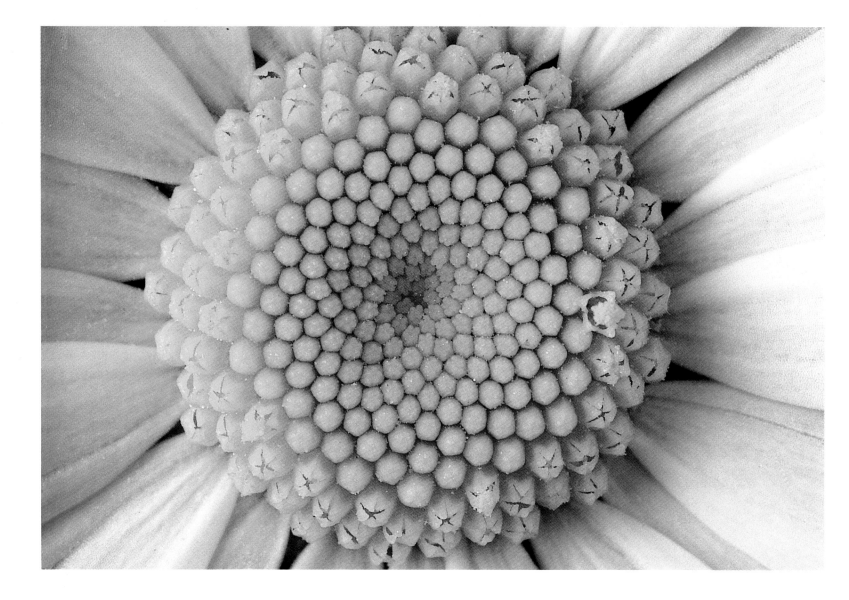

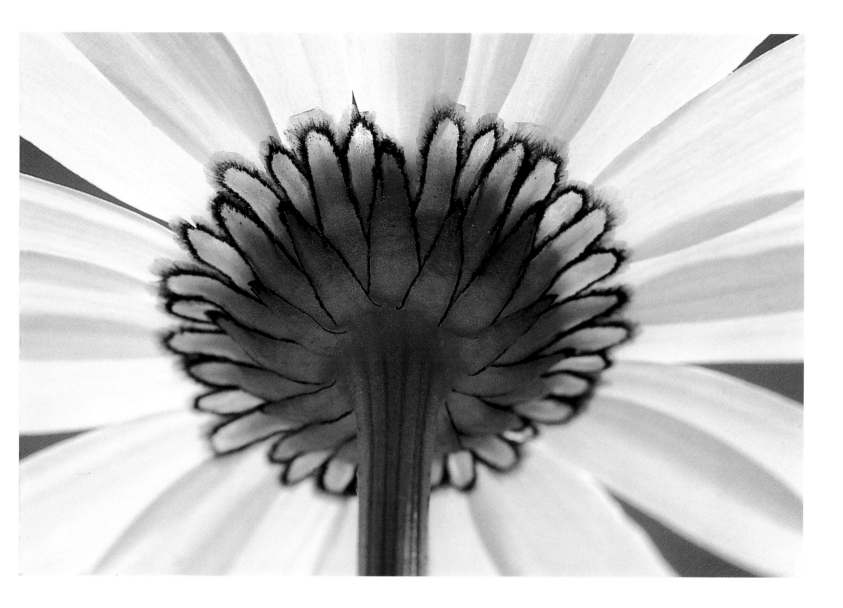

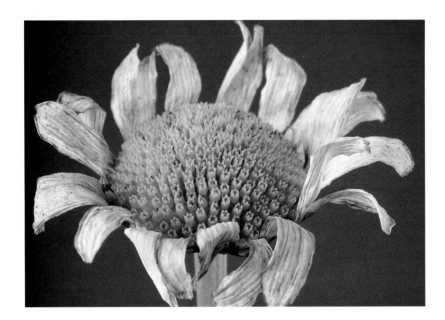

2/12